BORN Wild²

in YELLOWSTONE and GRAND TETON NATIONAL PARKS

photography and text by
STEPHEN C. HINCH & HENRY H. HOLDSWORTH

FARCOUNTRY PRESS

Right: Two pronghorn fawns enjoy using each other for a good scratch on a summer morning. Pronghorn are the fastest North American land mammal, and run at speeds near 60 miles per hour. STEPHEN C. HINCH

Far right: Grizzly bear 399 wanders through a meadow near Pilgrim Creek with her three spring cubs. Grizzly bears typically have two cubs at a time and often only a single cub, with three or four cubs being a rare occurrence. Bear 399 became Jackson Hole's most famous bear by having three sets of triplets starting in 2006. She has had at least six litters of cubs to date and is largely responsible for populating Grand Teton National Park with grizzlies. HENRY H. HOLDSWORTH

Title page: A red fox kit greets its mother with a kiss as she returns to the den with food for her litter of five.
HENRY H. HOLDSWORTH

Front cover: When this cub became too cold in the snow, he climbed on mom's back. Mom didn't mind, and it allowed her to focus on her search for food, knowing the cub was safely on her back. STEPHEN C. HINCH

Back cover, left: A very young and shy red fox kit ventures out from the shelter of its den. Red foxes can be red, black (also called silver), or a mix of the two colors. HENRY H. HOLDSWORTH

Back cover, right: A yellow-bellied marmot mother watches its young pup emerge from its den in a hollow Douglas fir tree.
HENRY H. HOLDSWORTH

ISBN: 978-1-56037-753-5

© 2019 by Farcountry Press

Photography © 2019 by Stephen C. Hinch and Henry H. Holdsworth. Text by Stephen C. Hinch and Henry H. Holdsworth.

For more information about our books, write Farcountry Press, P.O. Box 5630, Helena, MT 59604; call (800) 821-3874; or visit www.farcountrypress.com.

 Produced and printed in the United States of America.

23 22 21 20 19 1 2 3 4 5 6

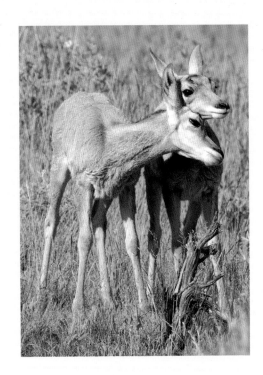

For my amazing daughter, Sophie Bell, who brings us more happiness than we ever thought possible.

—Stephen C. Hinch

This book is dedicated to my Mom, Shirley, who always encouraged me to pursue the things I loved.

—Henry H. Holdsworth

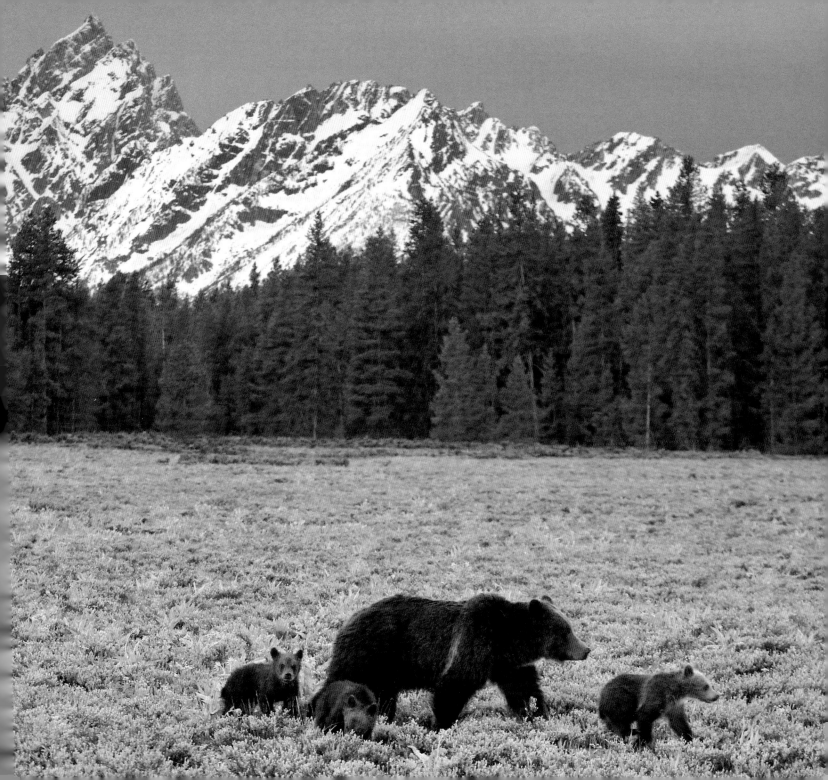

YELLOWSTONE

BY STEPHEN C. HINCH

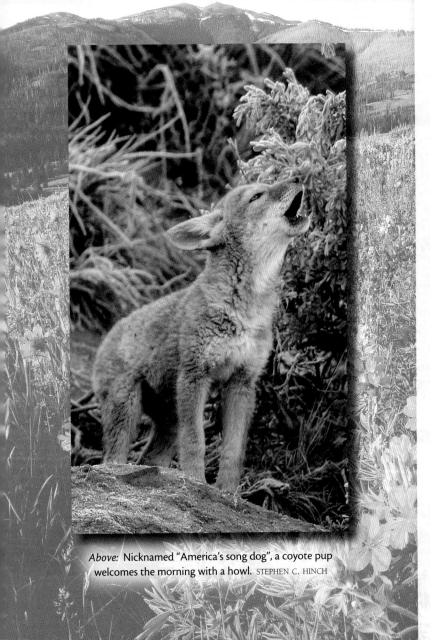

Above: Nicknamed "America's song dog", a coyote pup welcomes the morning with a howl. STEPHEN C. HINCH

Yellowstone National Park was designated as the the world's first national park on March 1, 1872. This beautiful and magical place was originally set aside to protect the incredible and diverse geothermal features found here, but today many people also come to see the abundant wildlife that calls Yellowstone home.

Each spring, life begins anew in the park as baby animals enter the wild world and begin their journey to adulthood in one of our planet's most incredible places. From tiny grizzly cubs to speedy pronghorn fawns, playful red fox kits to hungry baby birds, Yellowstone is home to many different species.

All those babies have one thing in common: they love to play! While mothers teach them important lessons about what to eat and where to find it, playing helps the little ones develop motor skills and other abilities that will help them survive in the wild.

Incredible displays of bubbling mud and boiling water, accented by mountain peaks and flower-filled meadows, create a dynamic and vast landscape for these babies to call home as they grow up wild in Yellowstone National Park.

GRAND TETON

BY HENRY H. HOLDSWORTH

The majestic peaks of the Teton Range rise up from the valley known as Jackson Hole to form one of the most spectacular backdrops in all of the Rocky Mountains.

Grand Teton National Park was established in 1929 to protect these mountains and expanded in 1950 to encompass much of the valley floor. And while the many glacially carved lakes and the mighty waters of the Snake River add striking foregrounds to these surroundings, the true heartbeat of the park lies in the remarkable array of wildlife that call the Tetons home. From moose to marmots, owls to otters, beavers to badgers, the diversity of animals literally brings this park to life.

As the days lengthen, and the deep snows and whites of winter give way to green leaves and colorful displays of wildflowers, new arrivals take center stage, and the amazing cycle of life begins anew. Bears emerge from hibernation, birds return from their winter wanderings, and newborns get their first glimpse of their world. For those who are willing to get out and explore, spring is truly a magical time of year to be in the Tetons.

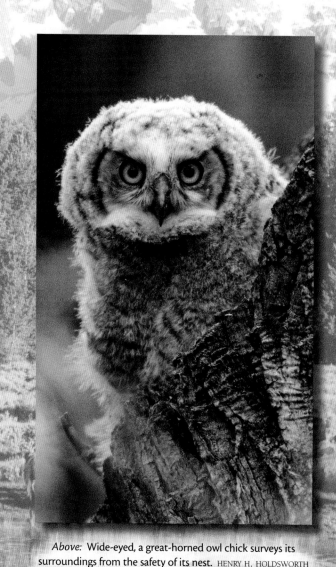

Above: Wide-eyed, a great-horned owl chick surveys its surroundings from the safety of its nest. HENRY H. HOLDSWORTH

Right: A young least chipmunk dines on a meal of dried grass near Granite Canyon. The least chipmunk is the smallest member of all the chipmunk species and the only one found in Grand Teton National Park. HENRY H. HOLDSWORTH

Far right: While elk can occasionally give birth to twins, these two calves are just playmates. Both stay close to one mother while the other grazes nearby with a small group of elk browsing the green grasses of Yellowstone's Madison River. STEPHEN C. HINCH

Below: A pair of Canada geese floats their armada of goslings along Flat Creek in the National Elk Refuge. May is a busy month for Canada goose families in the valley. HENRY H. HOLDSWORTH

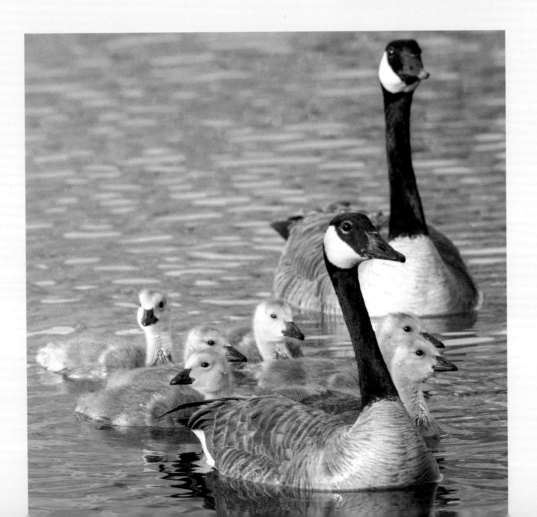

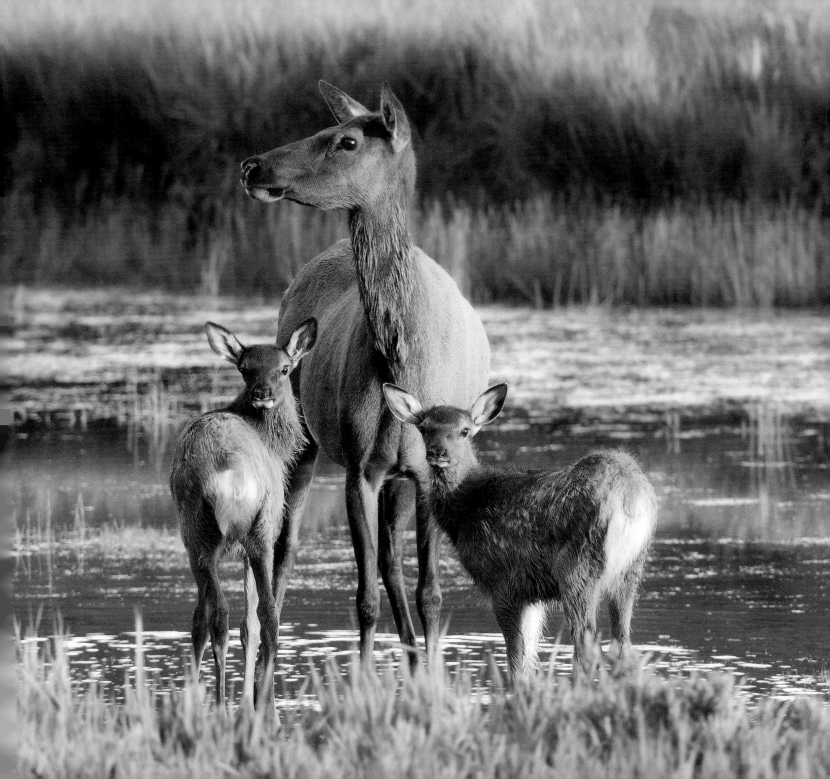

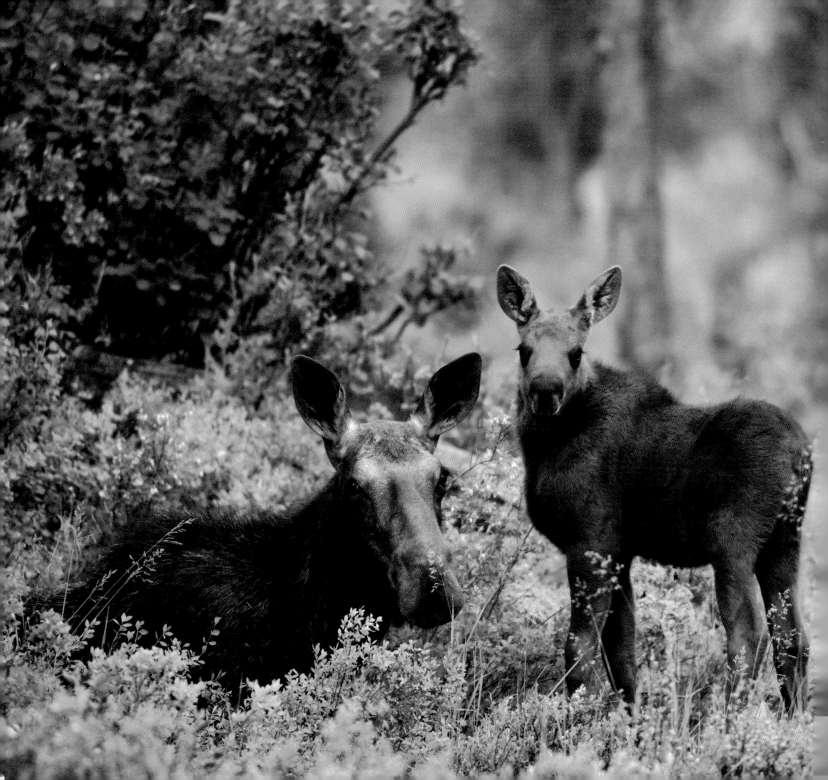

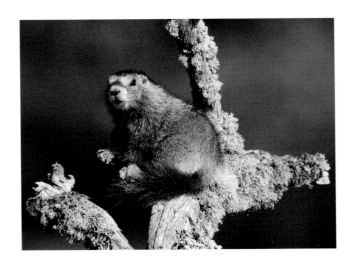

Left: A baby yellow-bellied marmot suns itself on a lichen-covered branch. Marmots are also known as "rock chucks" and "whistle pigs." They typically live in rocky areas and hibernate each winter starting in late August and emerging again in April. HENRY H. HOLDSWORTH

Far left: A cow moose and her newborn calf stick to the cover of the river bottom. Moose calves are born between late May and early June each year. This young calf will stay close to its mother for an entire year, until she gives birth to a new calf the following spring. HENRY H. HOLDSWORTH

Below: When black bear cubs leave the den with their mothers in early spring, they are tiny balls of fur. They grow quickly thanks to their mother's milk as well as food their mother teaches them to find and eat. But in between naps and feeding, bear cubs like to play and explore. This tiny cub near Yellowstone's Tower Fall finds this large tree fascinating. STEPHEN C. HINCH

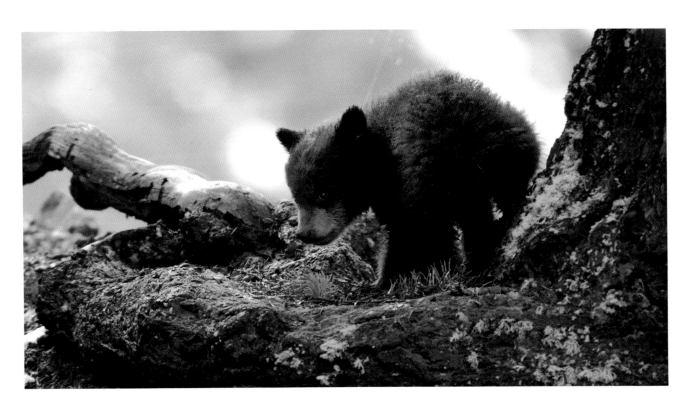

Right: A pair of baby Uinta ground squirrels warmly greet each other on a sunny summer day. Ground squirrels, locally known as "chiselers," are a common sight in summer months until late August, when they go into hibernation based on the length of the day. HENRY H. HOLDSWORTH

Far right: Unlike other babies of grazing animals, which spend the first week or two of life hiding in long grass or other protected places, bison calves must learn to move with the herd within hours. In the spring, when the rivers are high with snowmelt, river crossings are dangerous endeavors for young bison. This young calf swam with its herd across the Madison River in Yellowstone and safely reached the other side. Being in the middle of the herd helped shelter the calf from the river's strong current. STEPHEN C. HINCH

Below: A beaver kit dines on willow twigs with its mother in late summer. Schwabacher's Landing, a side channel along the Snake River in Grand Teton, is an excellent place to watch beavers as they come out of their lodges to feed and work in the evening. Beavers are nocturnal, active mainly between 6 p.m. and 6 a.m. HENRY H. HOLDSWORTH

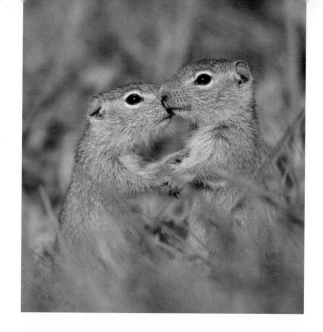

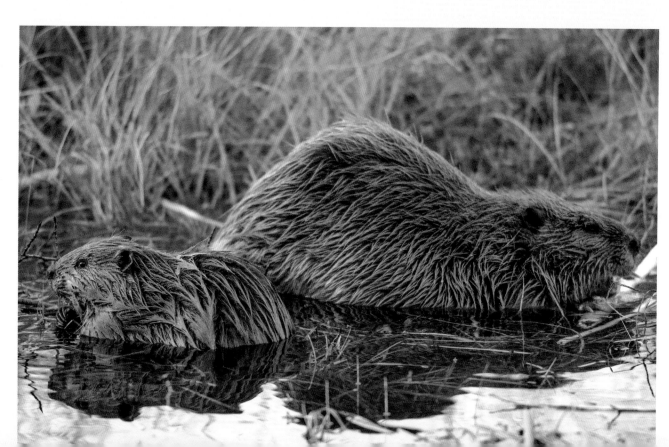

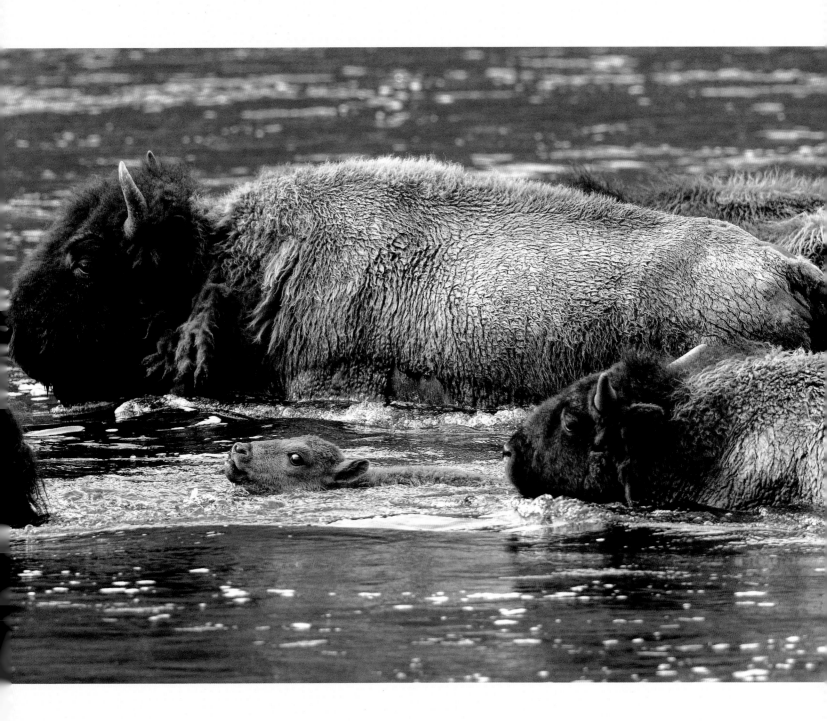

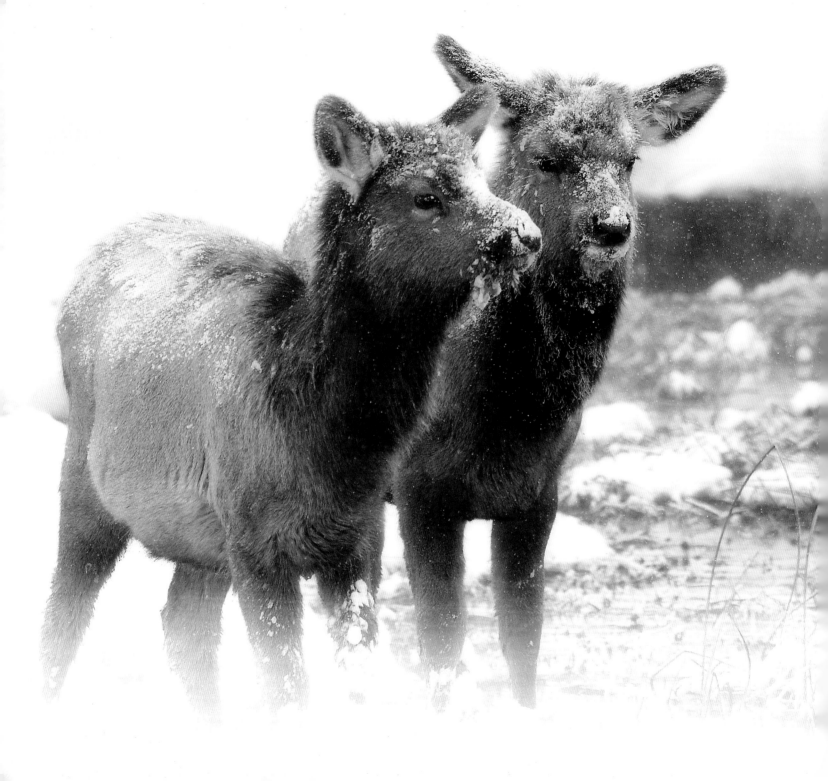

Left: These two elk calves were born in May or June. Yellowstone was green and warm for most of their lives, but now they are experiencing their first winter and have learned that once easily accessed vegetation is buried under feet of snow. Their thick coats will keep them warm during the long winter. STEPHEN C. HINCH

Below: Martens are normally found in dense pine forests, but this young marten, perhaps experiencing winter for the first time, left the safety of the forest to quickly move through an open meadow. Doing so can be risky for a young pine marten, as it becomes an easy target for birds of prey, but this little one made it safely across the meadow and back into the forest. STEPHEN C. HINCH

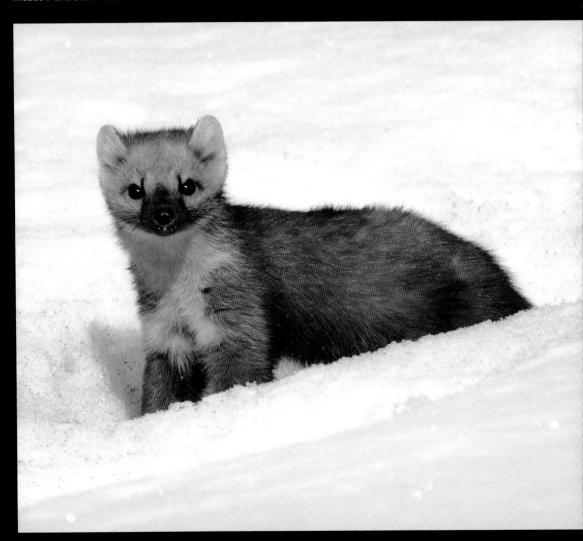

Right: Pika live in the high mountains where they thrive in the cool temperatures. They are more often heard than seen, and hikers in the high country can often hear them bleat. By the time the young emerge from the den, they are almost the size of their parents, like this young pika perched on a rock. STEPHEN C. HINCH

Far right: Bighorn sheep can be found in Yellowstone, but during the summer they prefer high mountain terrain, so many visitors may not see them. In May, when the lambs are born, they may still be found on cliff faces in lower elevations such as Gardiner Canyon or near Calcite Springs. These four lambs, like all youngsters, like to play. STEPHEN C. HINCH

Below: A young marmot shares a play session with its parent. Marmots spend most of the year in their dens and usually are only seen from May through August. But when they are active, their colonies are a busy place. Marmot colonies can be fairly large, and several generations may share the same colony. STEPHEN C. HINCH

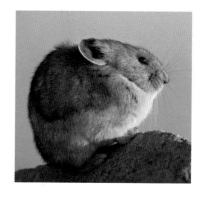

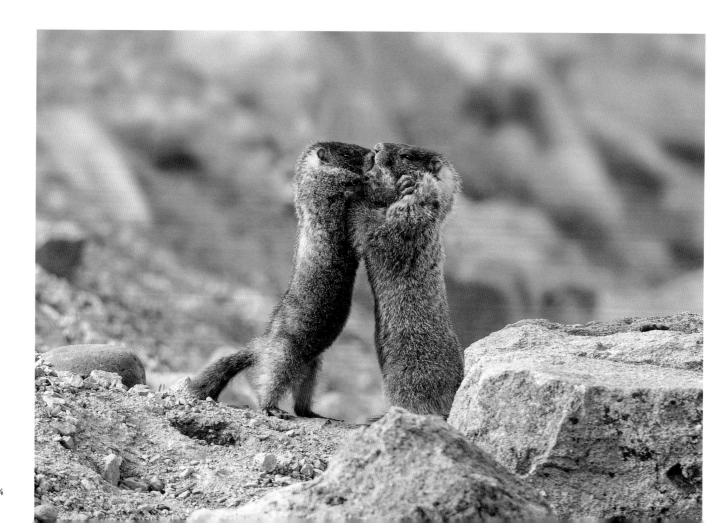

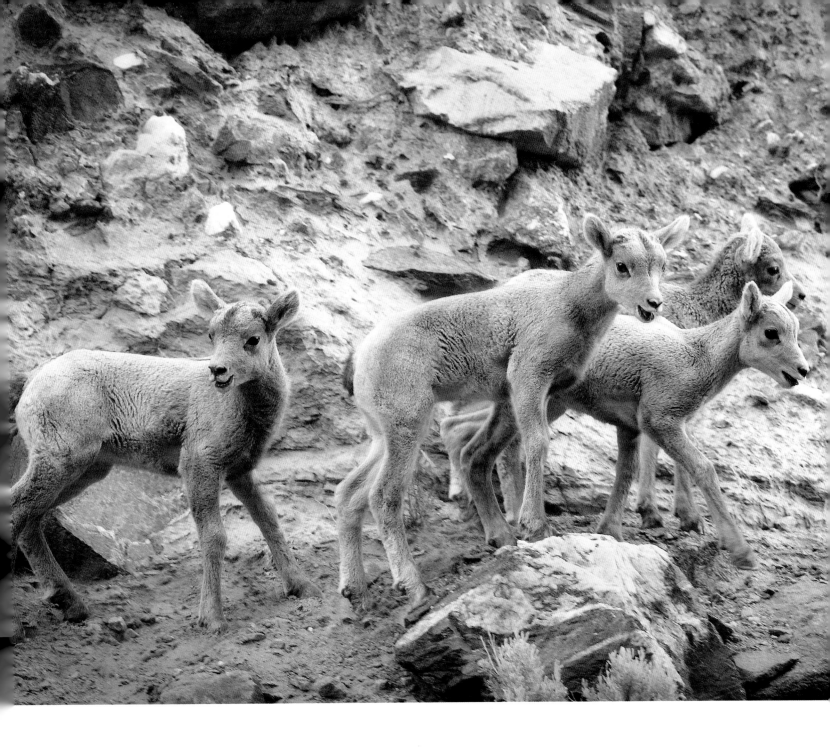

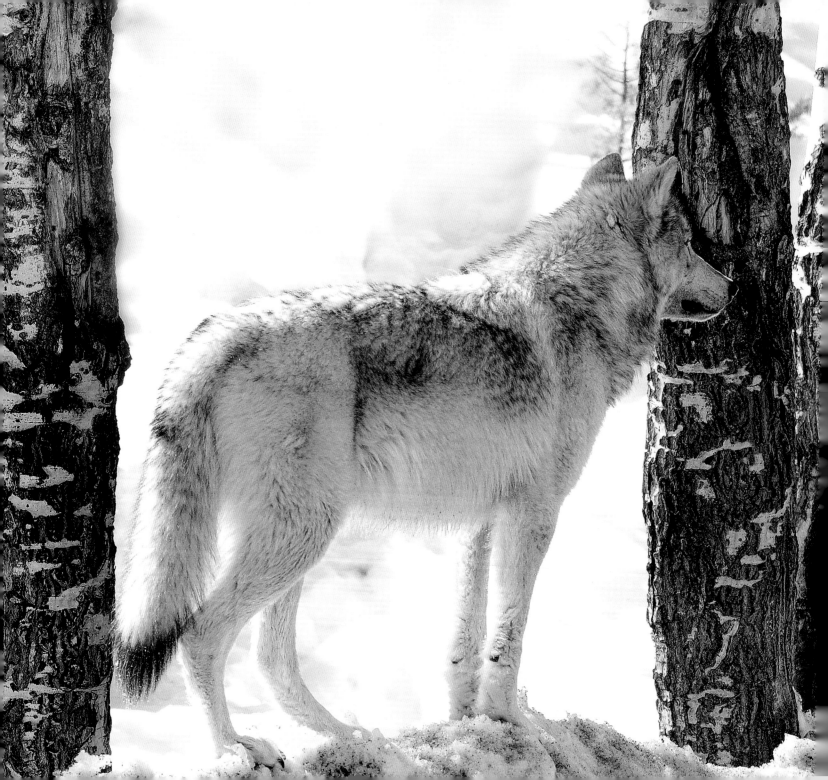

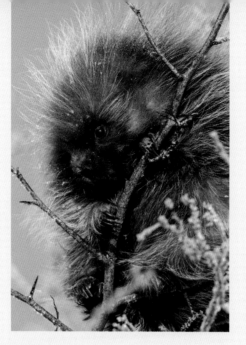

Left: A baby porcupine dines on a meal of twigs and buds during a cold morning along the Moose-Wilson Road in Grand Teton National Park. Porcupettes, as they are called, are born with soft, bendable quills that gradually harden over the first few days after birth. HENRY H. HOLDSWORTH

Far left: Wolves are born in the spring and will stay with their pack for some time. Males eventually disperse and join a different pack or attempt to start a new one. This young wolf, perhaps experiencing snow for the first time, makes its way through a stand of aspens to rejoin the safety of its pack. STEPHEN C. HINCH

Below: Snowshoe hares are brown in the summer but turn white in the winter, though their large feet, for which they're named, stay white year-round. This little one hides near a pine tree, its white coat camouflaging it well against predators. STEPHEN C. HINCH

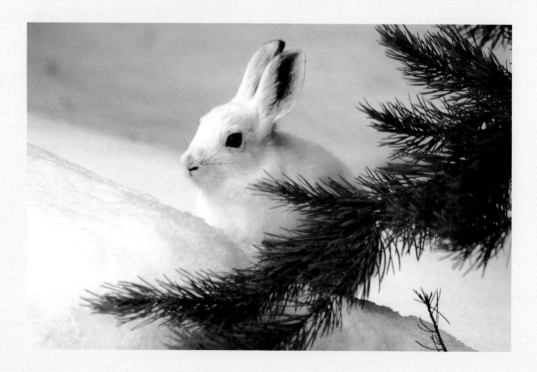

Right: Baby calliope hummingbirds are born with their eyes closed and without feathers. These tiny infants will grow up to be the smallest birds in North America, rarely exceeding three and a half inches when fully grown. HENRY H. HOLDSWORTH

Far right: A black bear cub waves to its sibling far below. Black bears are natural tree climbers, and nothing makes a better playground than a tree. Cubs often appear like acrobats as they scamper up and down a tree. Not only does climbing teach them useful skills that will help them survive, but it's also a lot of fun! STEPHEN C. HINCH

Below: Northern saw-whet chicks sit comfortably on an aspen branch. Saw-whet owlets leave the nest cavity when they are four to five weeks old and are independent from their parents at six to eight weeks. One of the smallest owl species, saw-whets are only five inches tall when fully grown. HENRY H. HOLDSWORTH

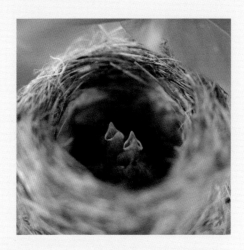

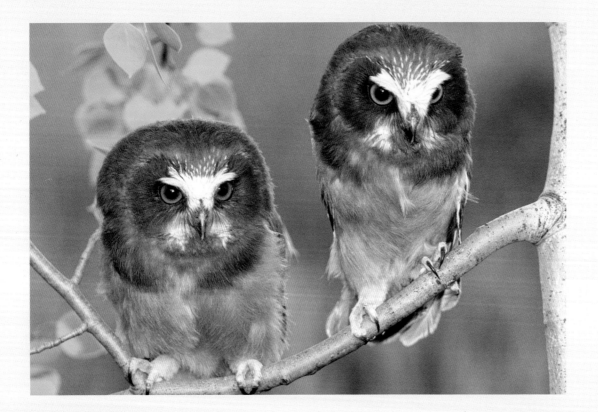

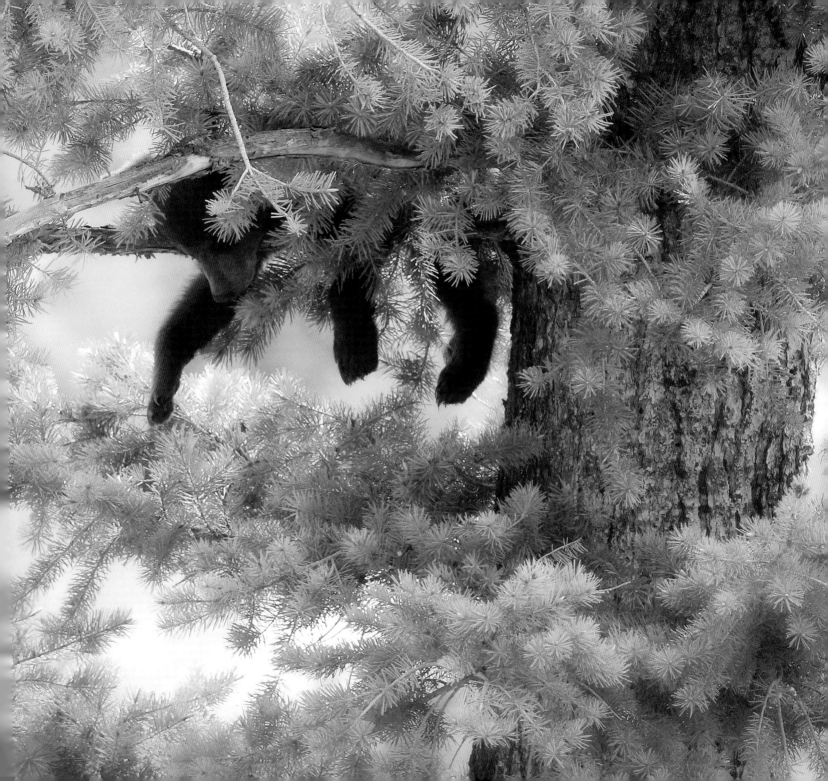

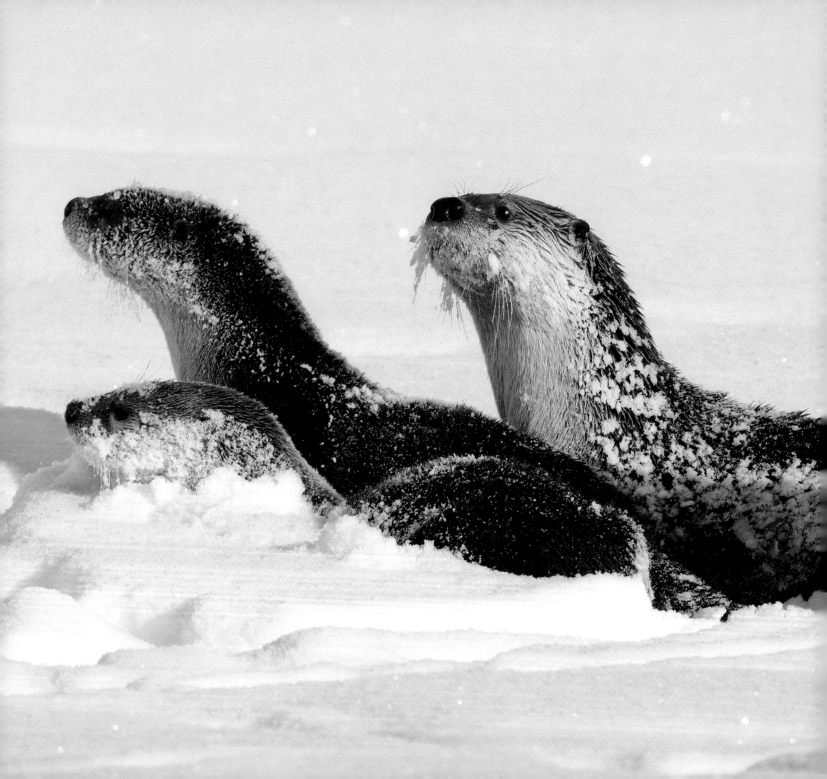

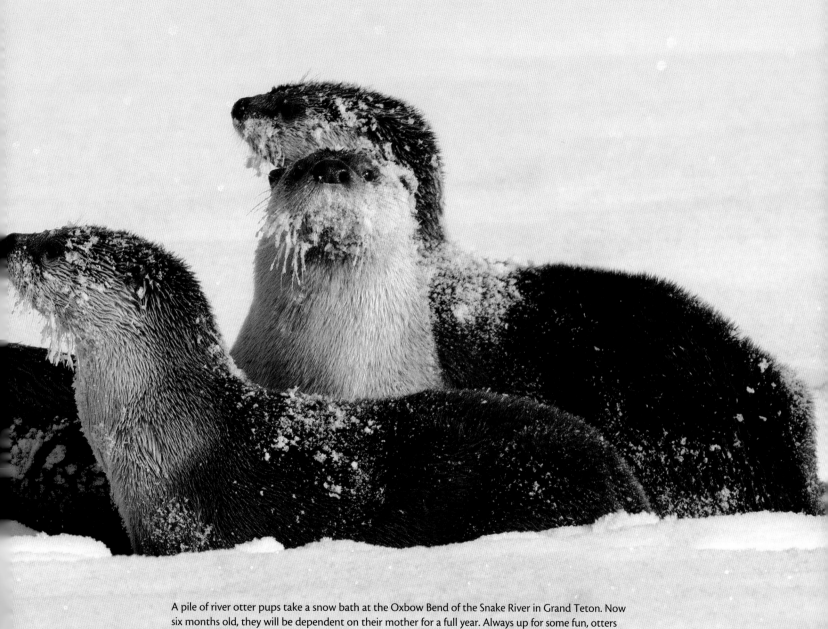

A pile of river otter pups take a snow bath at the Oxbow Bend of the Snake River in Grand Teton. Now six months old, they will be dependent on their mother for a full year. Always up for some fun, otters look like they enjoy life more than any other animal I have spent time watching. HENRY H. HOLDSWORTH

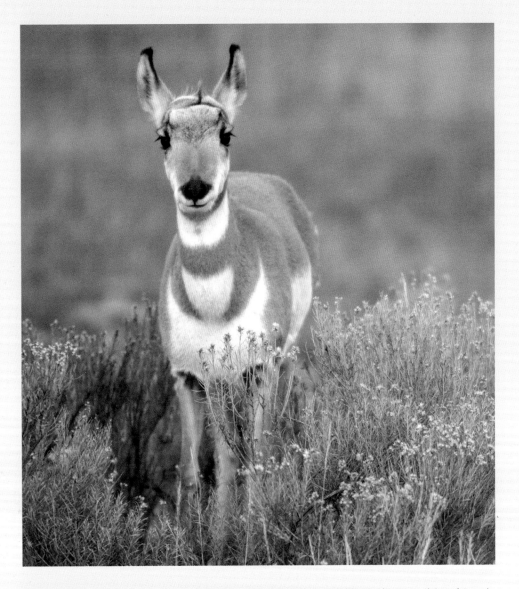

Above: A three-month-old pronghorn fawn pauses to survey its surroundings in the open plains of Grand Teton's Antelope Flats. Excellent eyesight and speed help the pronghorn elude predators such as coyotes, wolves, and mountain lions. HENRY H. HOLDSWORTH

Right: A female mallard and her newly hatched ducklings navigate the calm waters of Schwabacher's Landing. HENRY H. HOLDSWORTH

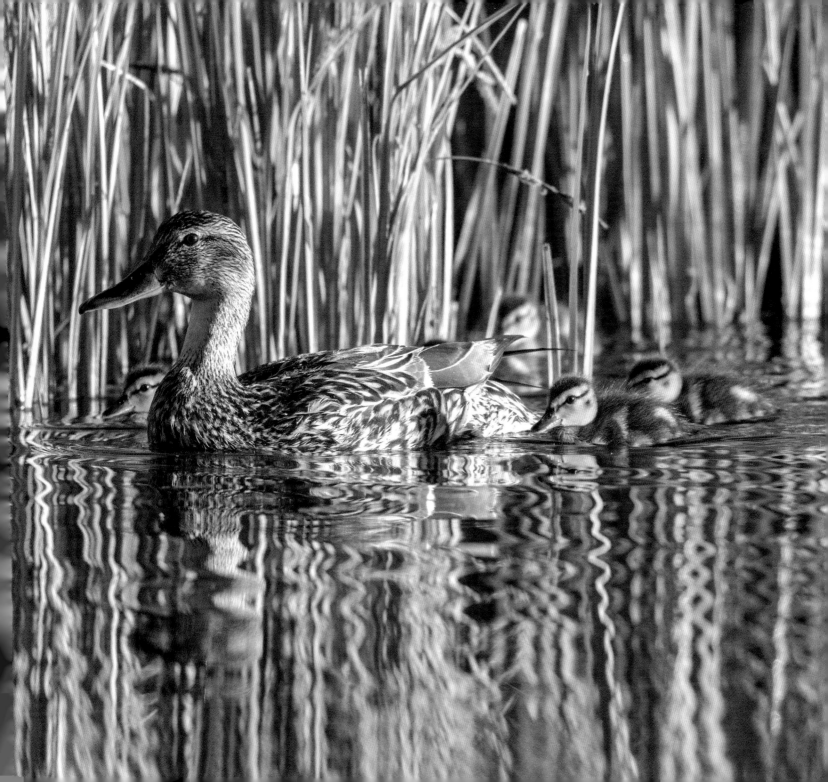

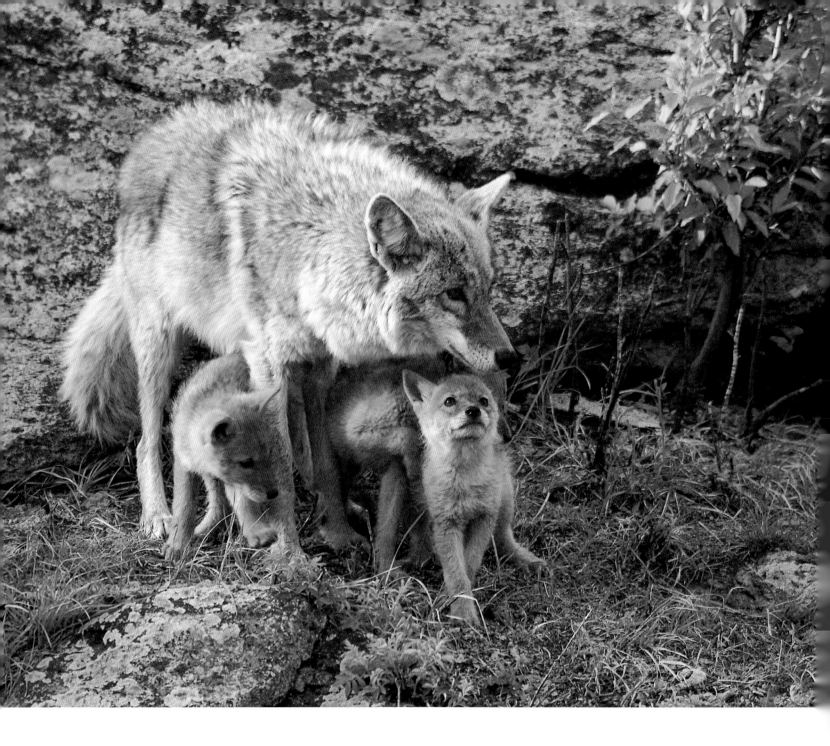

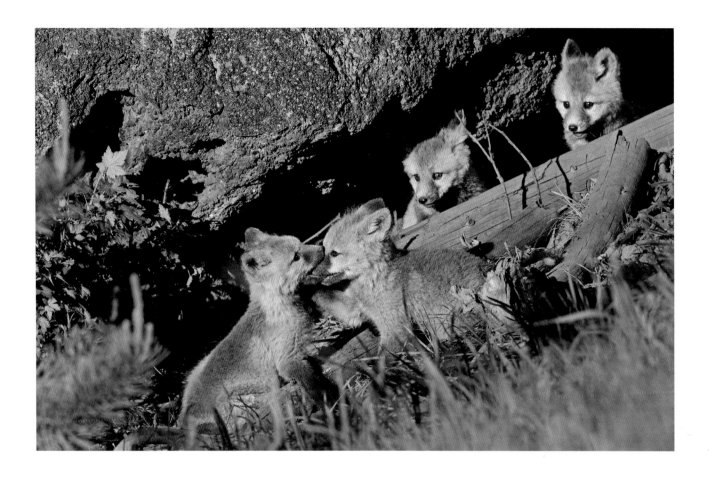

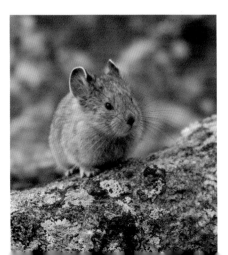

Above: Two fox kits enjoy play time together while two siblings watch, probably wondering when might be the best time to launch a sneak attack of their own. The red fox is one of three canine species found in Yellowstone. While common, none of the three species are especially easy to spot, as they usually den in places out of sight. STEPHEN C. HINCH

Left: A young pika is all ears, perched on a lichen-covered rock high up in Grand Teton's Cascade Canyon. Pika do not hibernate in the winter, instead gathering grasses and plants all summer to eat while in their den under the deep snows of winter. HENRY H. HOLDSWORTH

Far left: Coyotes, like foxes, typically den in secluded places, but occasionally a den might be chosen where park visitors can view the young pups at play. When this mother coyote returned to the den, the pups came out to see if she brought back food. After they warmly welcomed each other, each pup enjoyed a meal of milk. STEPHEN C. HINCH

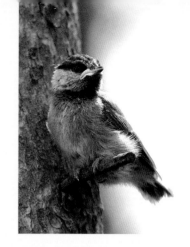

Right: Mountain chickadees are common throughout the Yellowstone area and are one of the few songbirds that stay year-round. They nest in tree cavities, using holes created by other birds such as nuthatches and small woodpeckers. This baby chickadee had fledged from its nest. After a short time on the ground, the little bird tested its wings and was able to move up into the safety of a nearby pine tree. STEPHEN C. HINCH

Facing page: A female mountain lion and one of her three kittens emerge from their den to check out the scene on the National Elk Refuge. Shy, nocturnal, and very stealthy, mountain lions are rarely seen but are an important predator in the Jackson Hole area, stalking prey that includes elk, deer, pronghorn, hares, and porcupines. HENRY H. HOLDSWORTH

Below: Mule deer are commonly found during the summer throughout Yellowstone. Fawns are born in late June into July, but by late August they may have already lost their white spots as they grow in their winter coat. As cooler weather returns with snow soon to follow, these two will migrate out of the park to more suitable winter habitat. STEPHEN C. HINCH

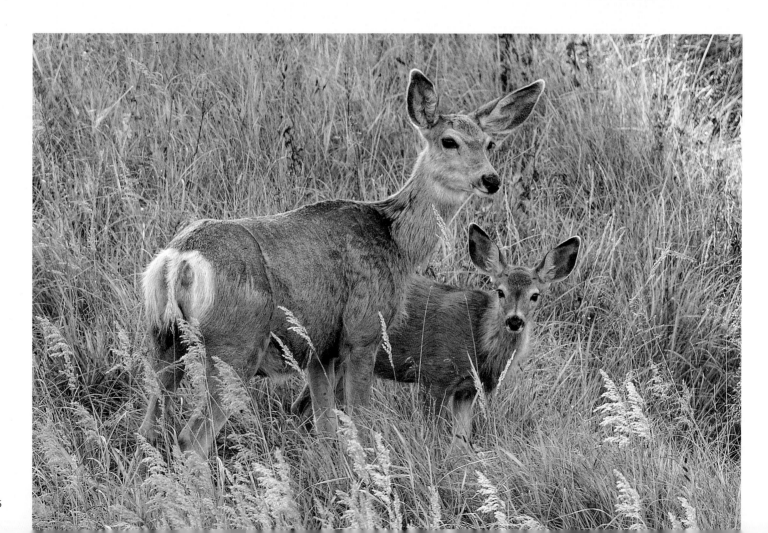

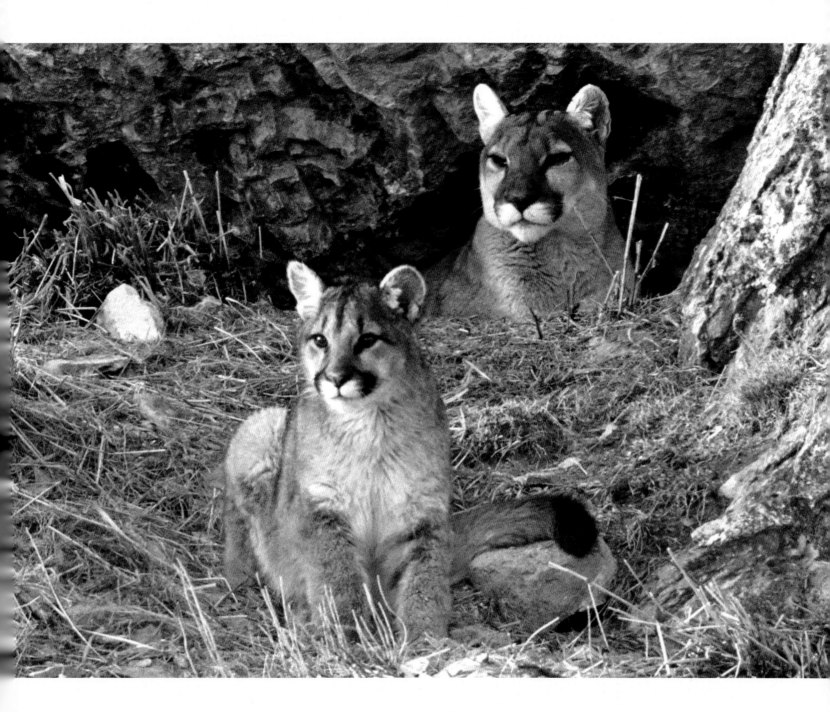

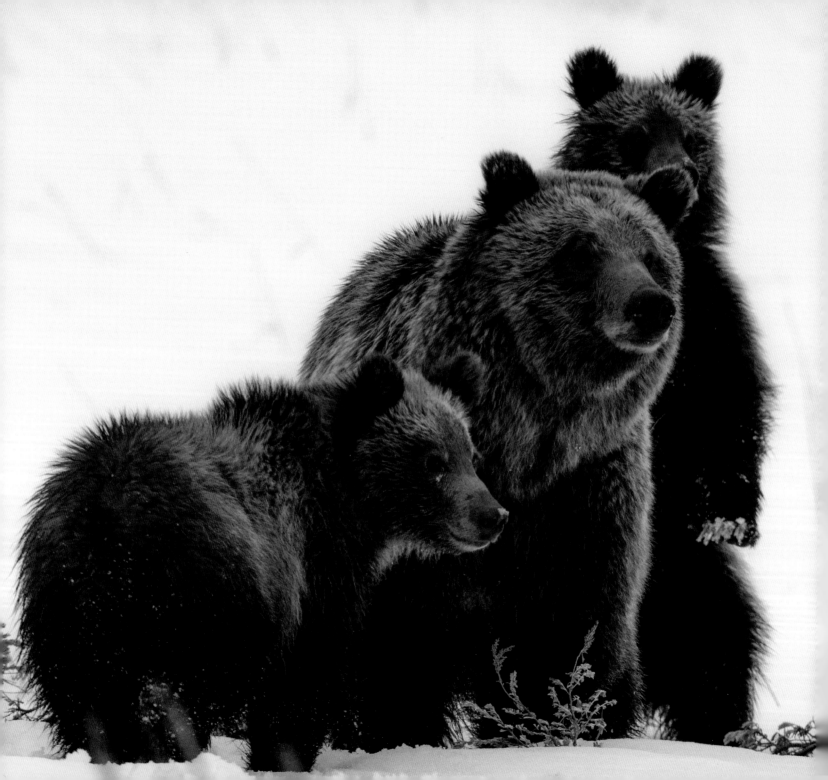

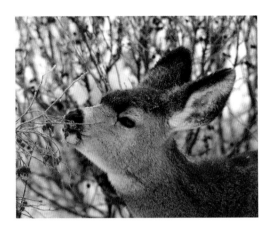

Left: A mule deer fawn dines on a delicacy of frozen berries in early winter. HENRY H. HOLDSWORTH

Far left: Grizzly bear 610 and her two yearling cubs wander through the spring snow near Oxbow Bend in Grand Teton National Park. Number 610 is the daughter of bear 399, from her original set of triplets (see page 2). Born in 2006, she has now had several litters of her own. Her cubs will stay with her for more than two full years before they are left to fend for themselves. HENRY H. HOLDSWORTH

Below: This calf was born late in the season, as it is rare to see a bison calf still orange in color at the start of winter. Bison lose their colorful baby fur after a few months, but until that time they go by the nickname "red dogs." HENRY H. HOLDSWORTH

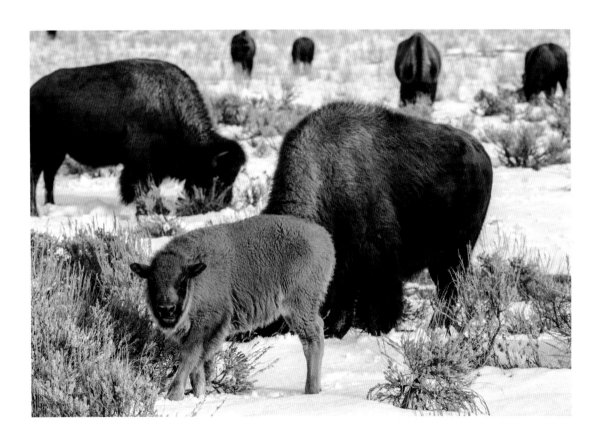

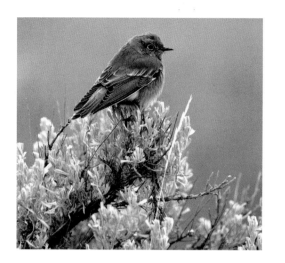

Right: A juvenile mountain bluebird sits pretty in the sagebrush, its plumage complementing the dusky foliage. HENRY H. HOLDSWORTH

Far right: Everybody wants to see a moose! While most members of the deer family prefer open meadows, moose prefer forests or willows. This can make them hard to find despite being the largest of all the deer. So when a moose calf follows its mother out of the forest and into the sagebrush, it's an exciting wildlife sighting! STEPHEN C. HINCH

Below: Badgers are born in the den in the spring, usually in April or May, and will stay with their mother during the summer, until around July or even August. They are otherwise solitary animals, so once they leave the den, they live alone. During winter, they're rarely seen, as they spend the cold months underground. STEPHEN C. HINCH

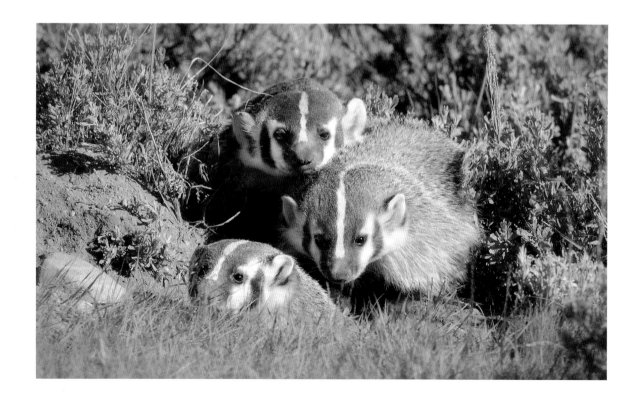

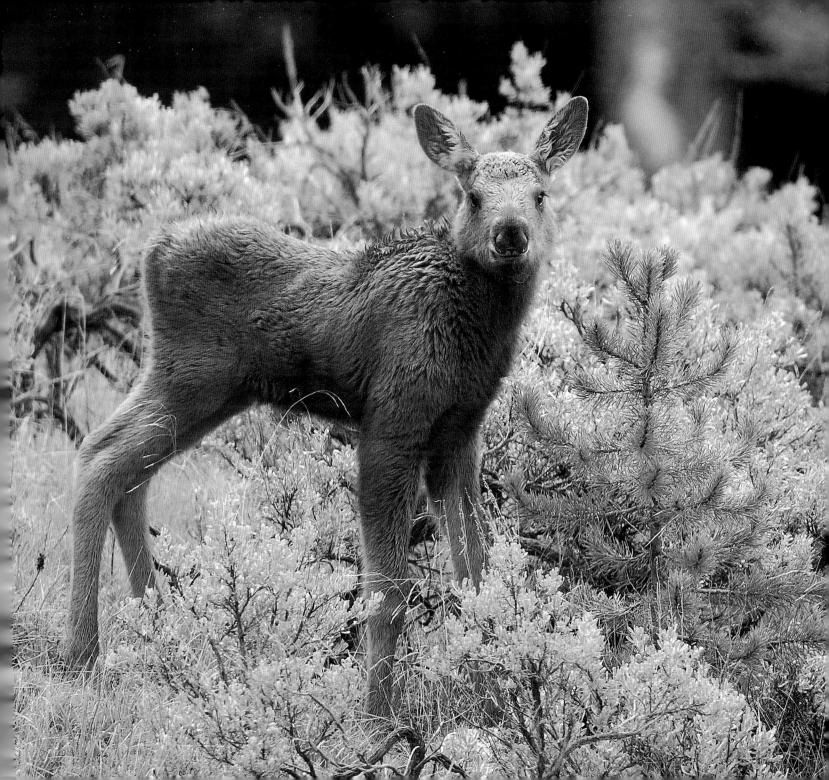

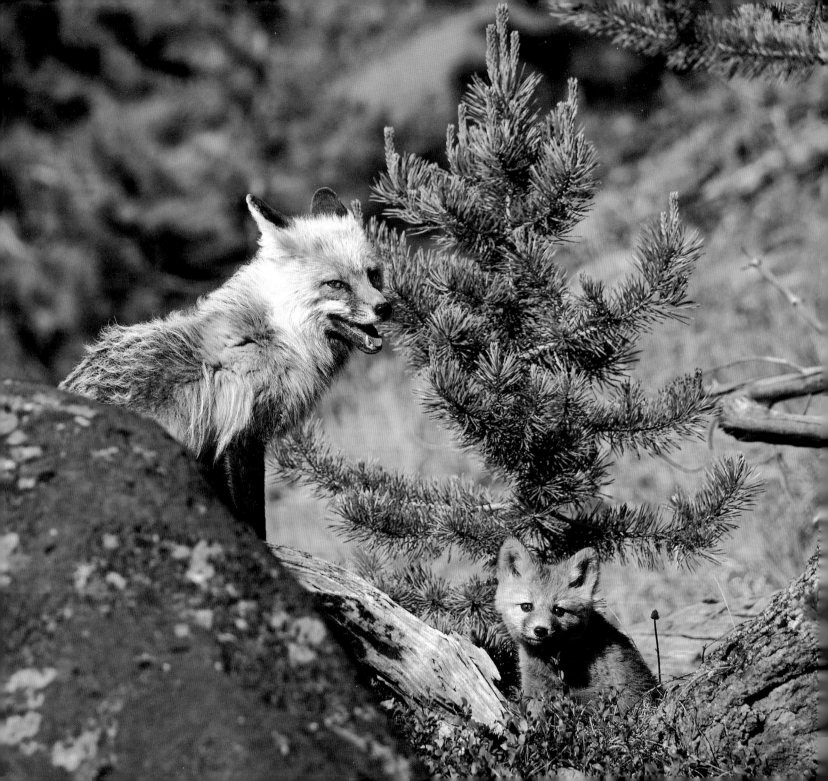

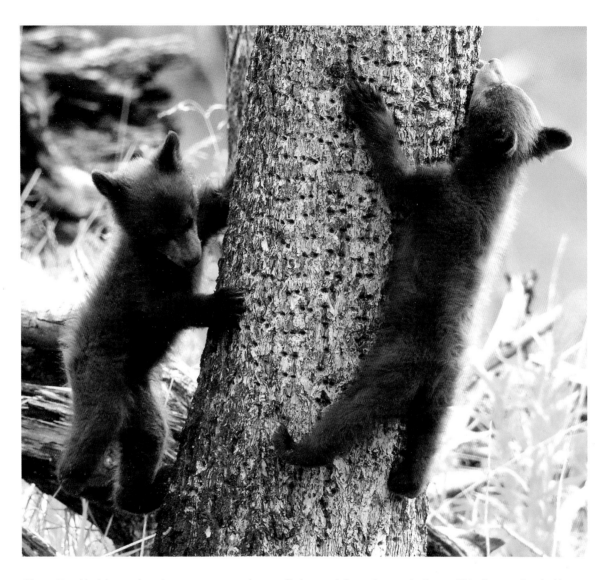

Above: Two black bear cubs enjoy a game to see who can climb up and down the tree the fastest. This pine tree, lined with holes from a busy woodpecker, provided a great jungle gym for these cubs, who spent a good deal of time chasing each other up and down it. STEPHEN C. HINCH

Left: Mom is never far away! At least when she's not out hunting to feed her family. This red fox vixen was looking for a place to take a short rest, but one kit wouldn't let her out of its sight, following her up the hillside a short distance, but never moving too far from the safety of the den. Being a fox mother can be just as exhausting as being a human mother! STEPHEN C. HINCH

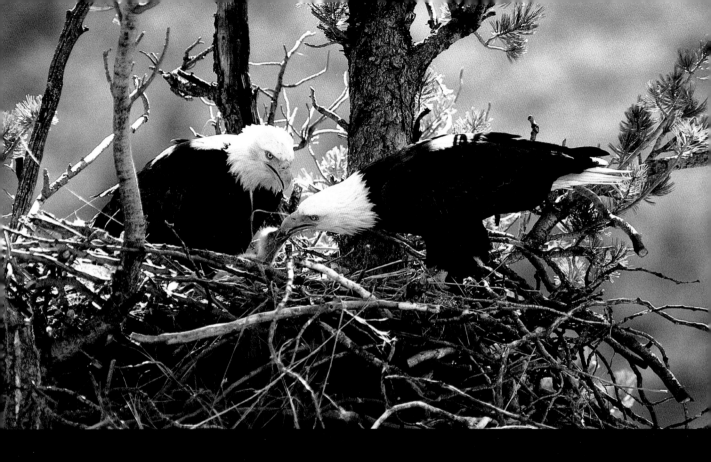

Above: A bald eagle pair feed their two-week-old chick a breakfast of cutthroat trout high above the Snake River in Grand Teton National Park. HENRY H. HOLDSWORTH

Right: Ducklings are a common sight on Yellowstone's waterways in the summer months. These tiny blue-winged teal ducklings swam behind their mother along Alum Creek as she foraged in the shallow water. STEPHEN C. HINCH

Facing page: Less than forty-eight hours old, a trumpeter swan cygnet gets a little reassurance from its attentive mother. HENRY H. HOLDSWORTH

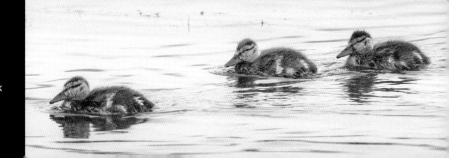

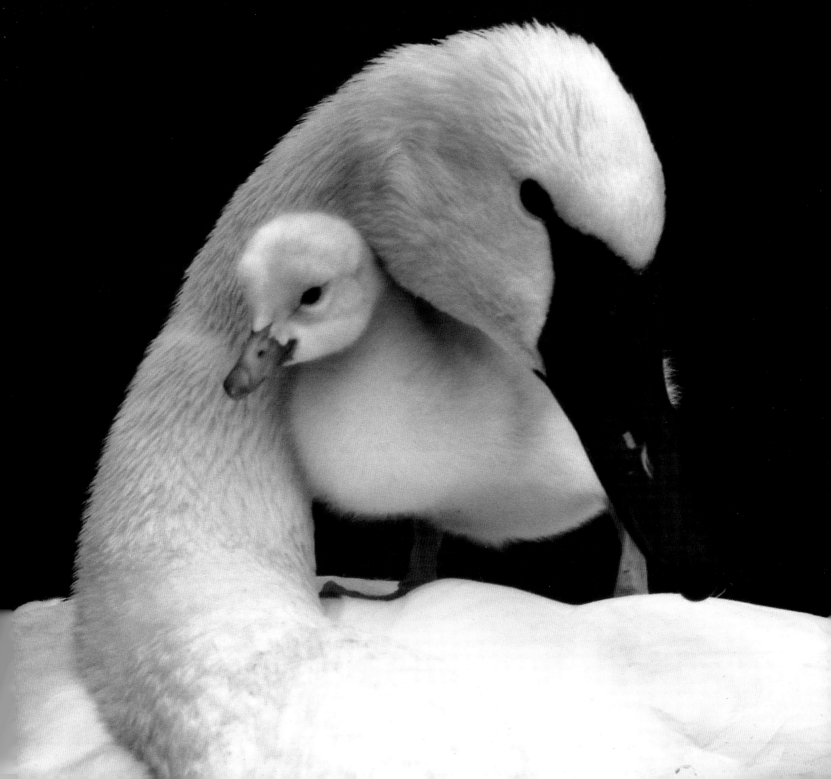

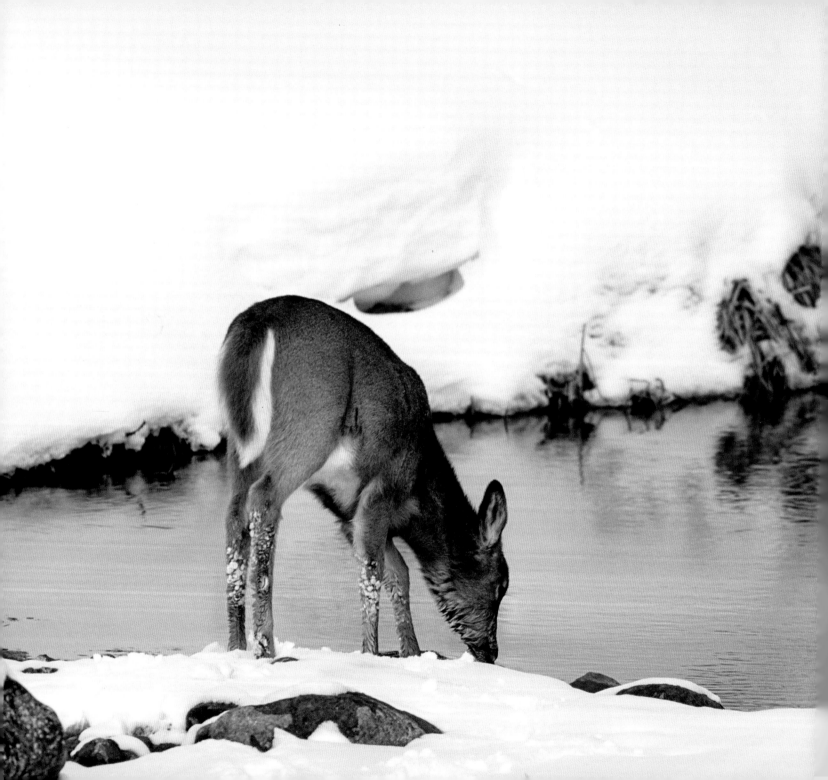

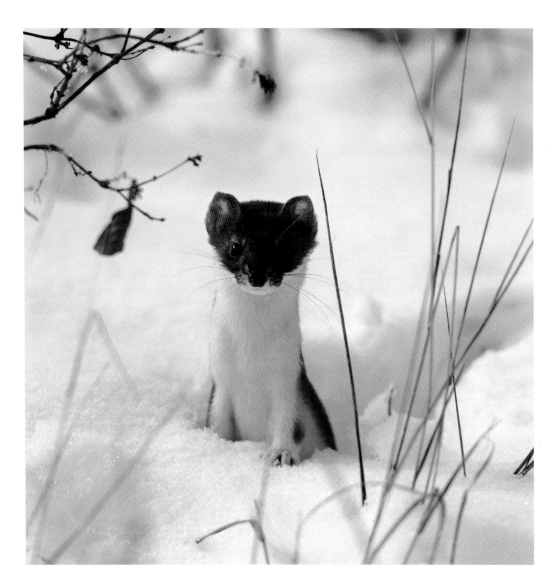

Above: A young long-tailed weasel, captured here in its summer coat, pauses while hunting for voles under the first snow of the season. Once the snow flies, it takes about eight days to go from summer brown to winter white, when it will then go by the name ermine. HENRY H. HOLDSWORTH

Left: A white-tailed deer fawn takes a cold drink near the base of the Tetons. Whitetails are a rare sight in Jackson Hole, with mule deer being the more common species in the area. HENRY H. HOLDSWORTH

Right: There's nothing cuter than a baby pronghorn with its long legs and delicate features. Luckily, young fawns begin to appear on the landscape with the emergence of the first summer flowers, allowing for a beautiful photo opportunity! STEPHEN C. HINCH

Below: A grizzly bear spring cub kicks up its heels while relaxing in a field of desert parsley. HENRY H. HOLDSWORTH

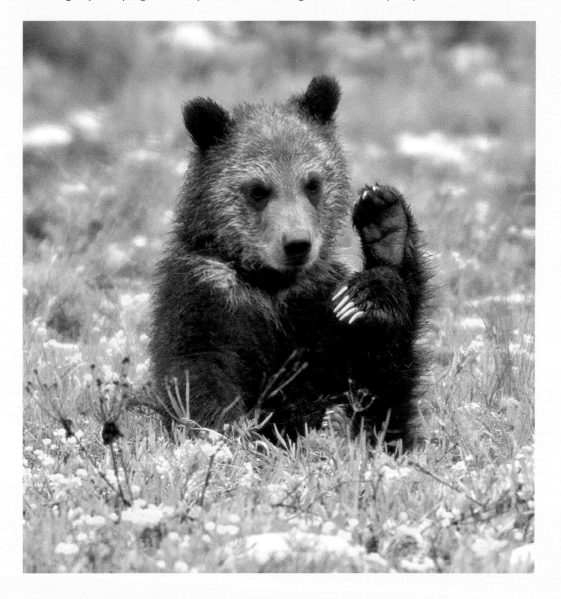

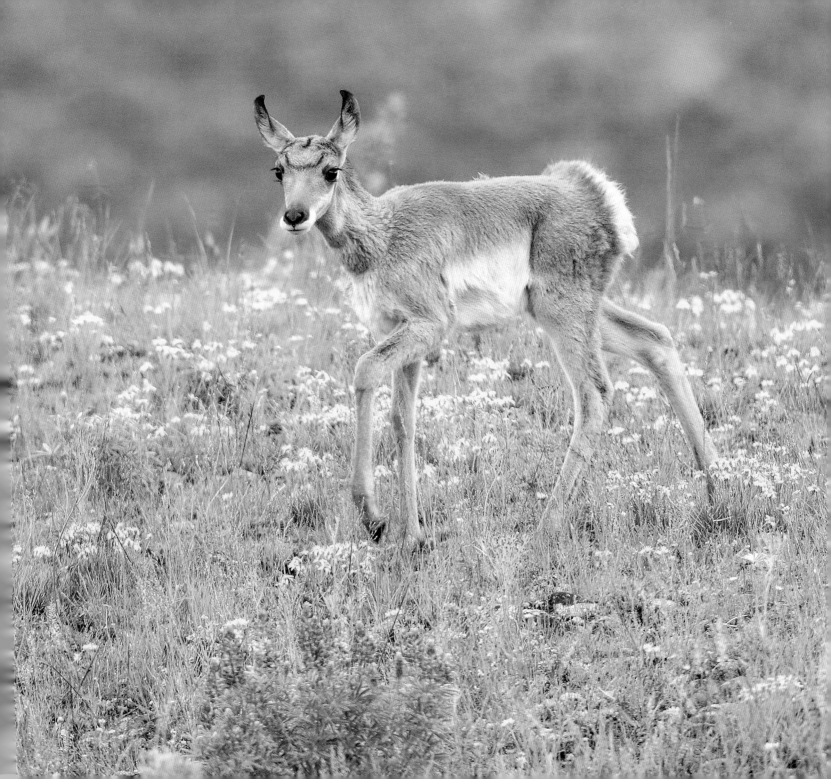

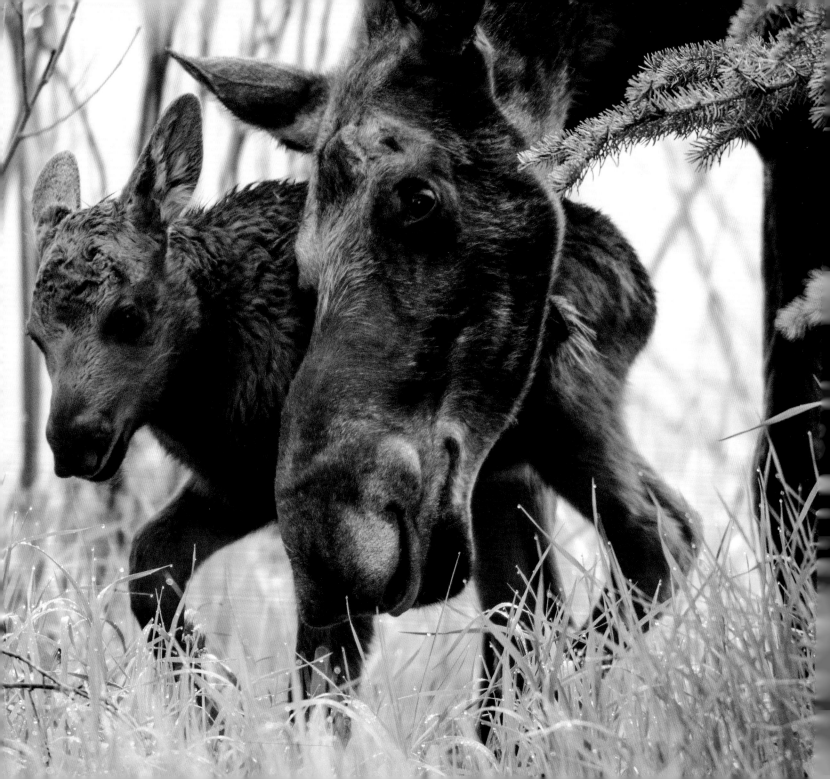

Left: A newborn moose calf tries out its still wobbly legs with a gentle nuzzle from its very protective mom.
HENRY H. HOLDSWORTH

Below: Coyote pups are awfully cute at six or seven weeks old. HENRY H. HOLDSWORTH

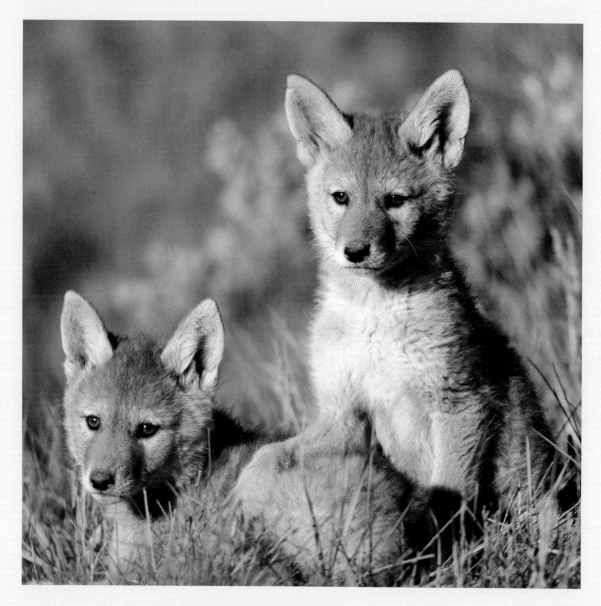

Right: A curious great horned owl chick peeks through a crack in its nest in a broken-off cottonwood tree. HENRY H. HOLDSWORTH

Far right: Grizzly sows are highly protective of their cubs, and a smart person keeps a safe distance! I photographed this sow with her two cubs with a long telephoto lens from the safety of a vehicle, parked off the side of the road, of course. Mom still keeps a watchful eye to make sure no danger comes to her tiny cubs. STEPHEN C. HINCH

Below: A pile of coyote pups huddle together for warmth just outside their den on Mormon Row in southeastern Grand Teton National Park. HENRY H. HOLDSWORTH

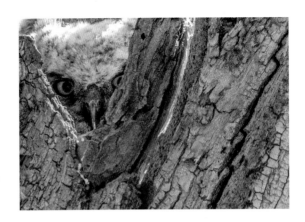

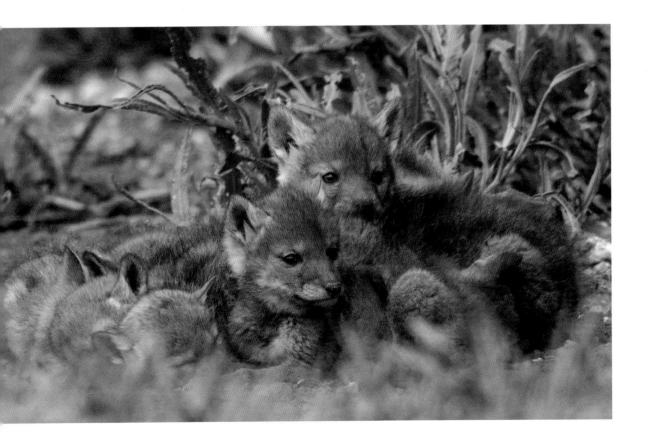

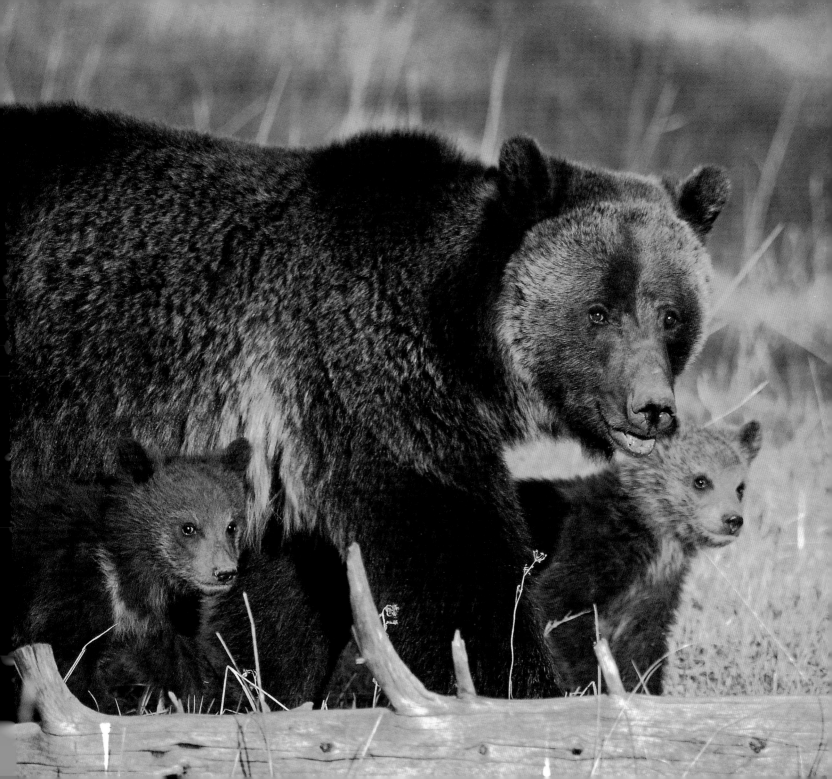

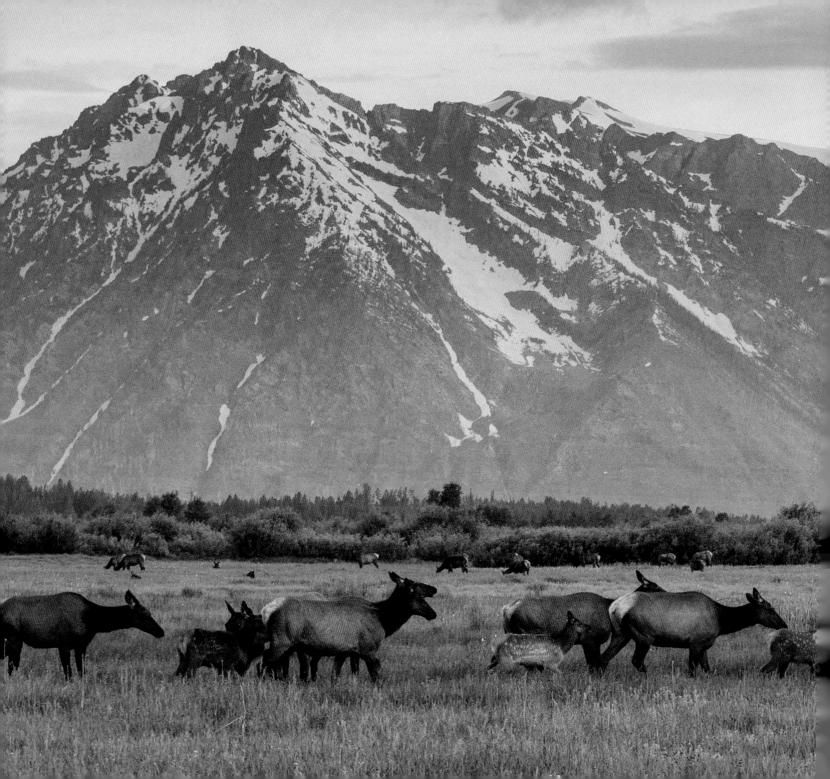

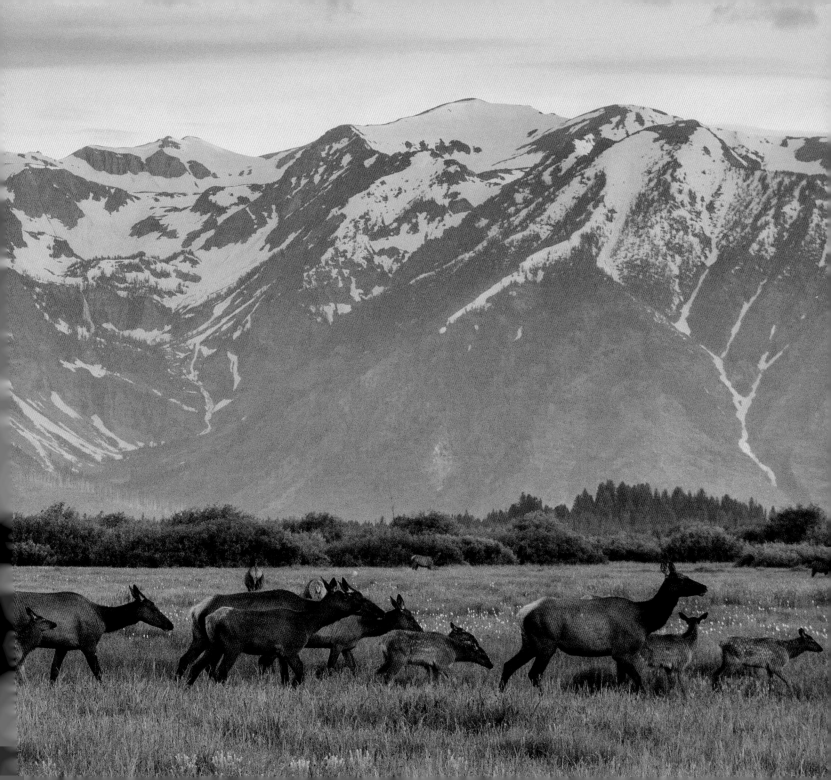

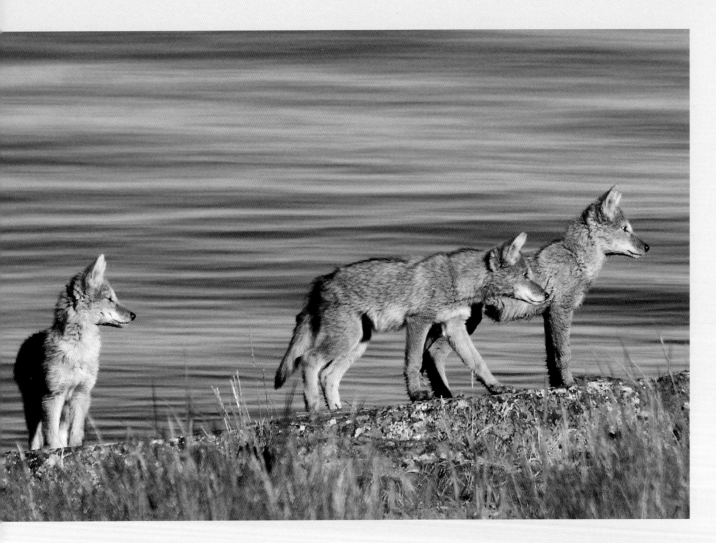

Above: What could be better than finding a coyote den right on the edge of Yellowstone Lake? These three kits often played along the lakeshore. That was until a curious grizzly showed up one day, and the mother coyote quickly moved her babies to a safer location. STEPHEN C. HINCH

Right: Otters may be the most playful of all animals in Yellowstone, youngsters and adults alike. This otter family enjoys a moment to groom each other. This behavior not only helps otters keep clean but is also a time to bond with one another. STEPHEN C. HINCH

Previous pages: A herd of cow elk and their calves migrate through the meadows of Willow Flats near Jackson Lake in Grand Teton National Park. HENRY H. HOLDSWORTH

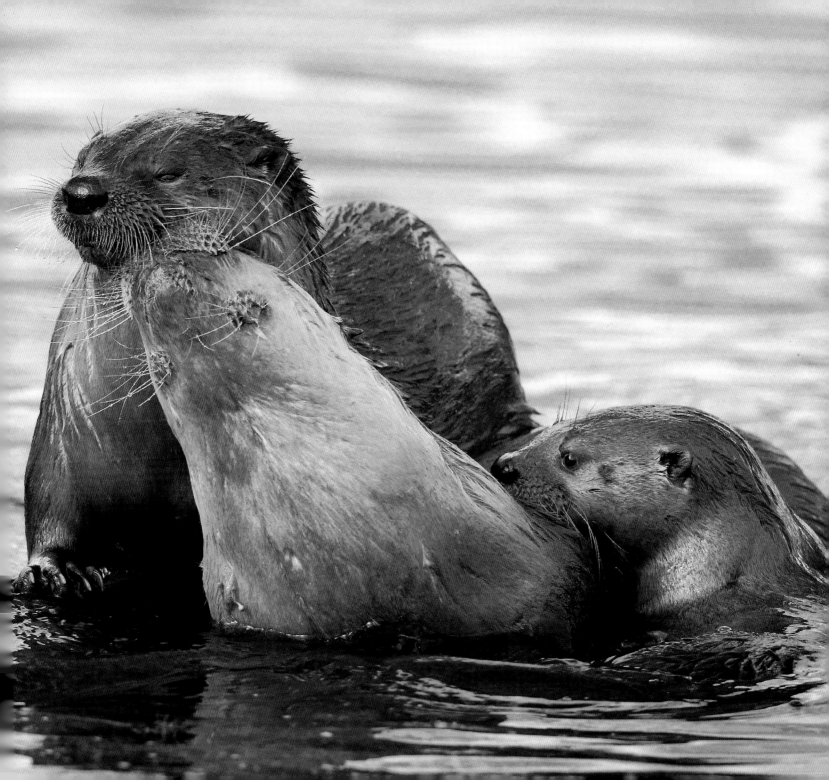

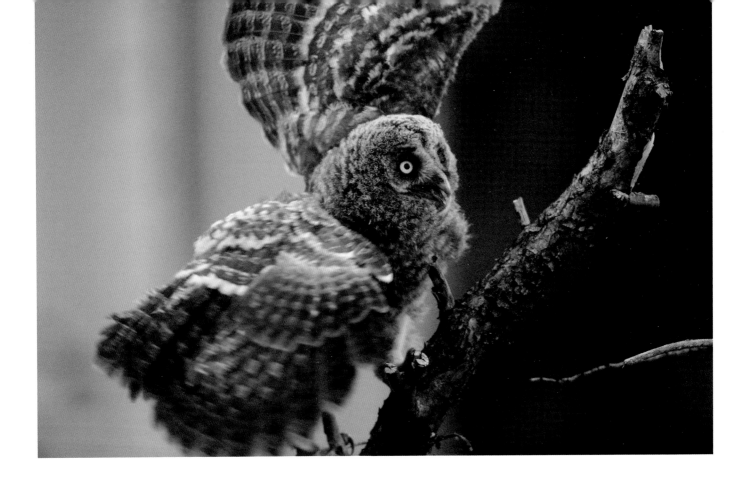

Above: A great gray owlet uses its wings for balance while navigating toward a safe perch on a low-hanging branch. Although fledged from the nest, it is still too young to fly. HENRY H. HOLDSWORTH

Right: The American dipper is a fascinating bird in that its diet consists of insects found below the surface of streams and rivers. A year-round resident of Yellowstone, these small birds can often be seen standing on rocks in or on the edge of a river watching for prey. When they spot it, they dive in and catch it underwater. A natural oil on their feathers provides insulation from the cold water, while an extra eyelid helps them to see underwater. STEPHEN C. HINCH

Far right: These two grizzly cubs exhibit a "natal collar," or white band, around the neck and shoulders. As the cubs grow older, this band will disappear. Even though momma grizzly is busy searching for a snack, she still has a watchful eye on her cubs, who seem more interested in what's going on around them than in searching for food. STEPHEN C. HINCH

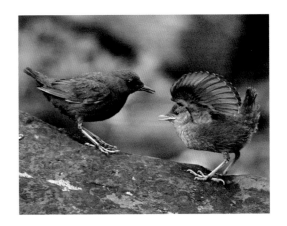

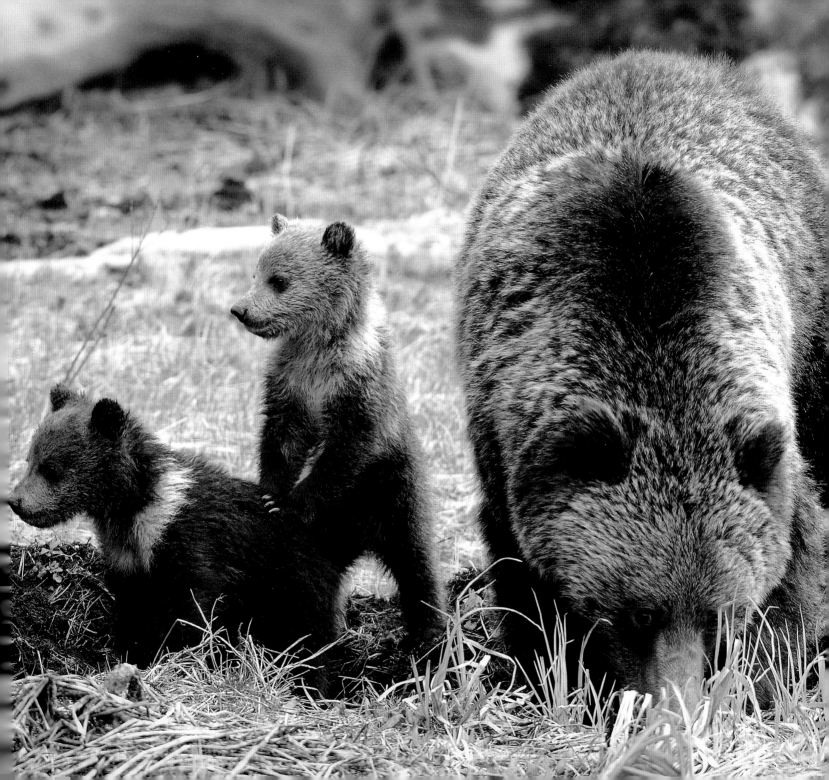

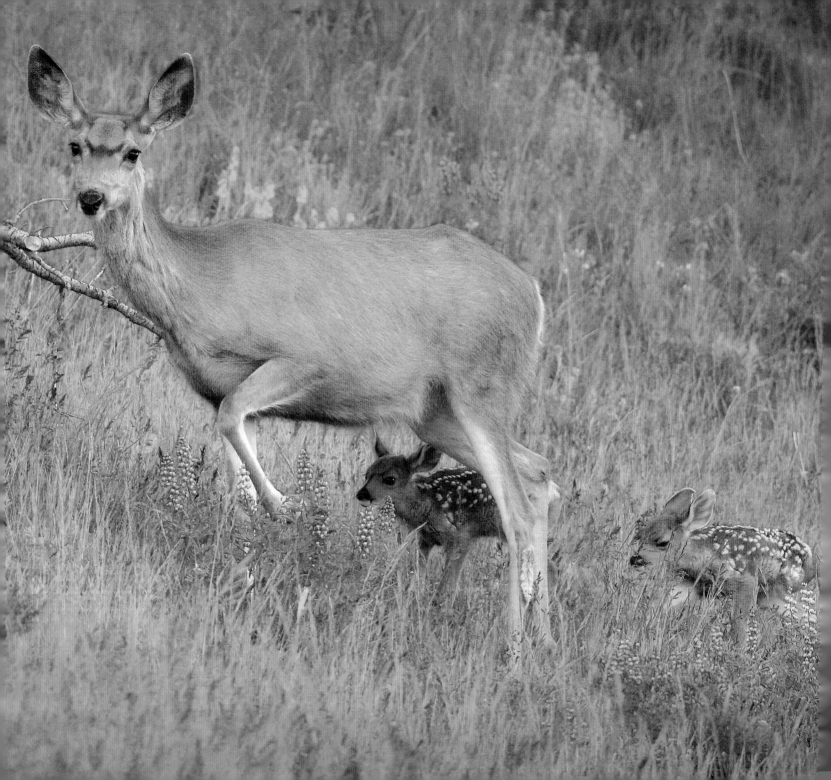

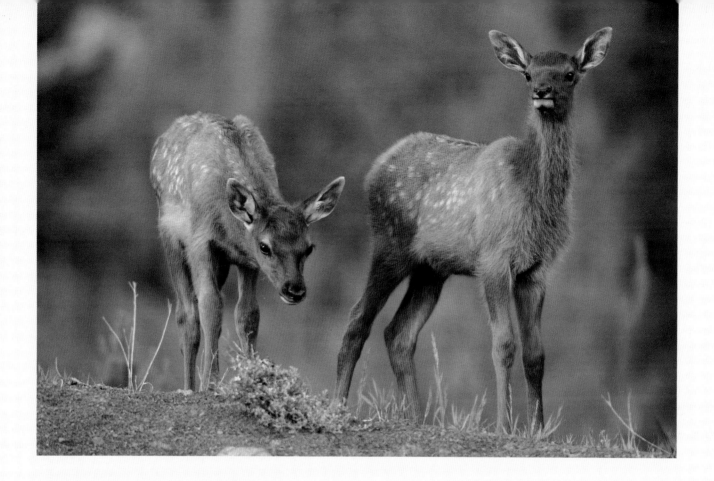

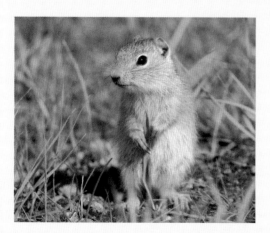

Above: Like all babies, young elk enjoy the companionship of others. It's not uncommon to see babies paired up playing or just hanging out together until it's time to return to mom for a meal. These two elk calves keep each other company while the adult elk in the herd graze nearby. STEPHEN C. HINCH

Left: Unita ground squirrels are probably the most common mammal in Yellowstone National Park. Their colonies can be found in open meadows throughout the park; in June, the small youngsters emerge into the world. STEPHEN C. HINCH

Far left: Mule deer usually give birth to a single fawn in late June or early July; occasionally they have twins. At first, I didn't even notice these tiny newborns as they followed their mother through the grass. The mother moved her twins near the top of the hill where the grass was taller, and they hid themselves. Even though I saw where they bedded down, they were so well concealed, I couldn't spot them at all. STEPHEN C. HINCH

Facing page: Elk are common around Mammoth Hot Springs in Yellowstone, and occasionally they'll walk near the terraces as they search for browse. While the elk around Mammoth may be accustomed to people, they should not be approached but rather enjoyed from at least 25 yards away, per park rules. STEPHEN C. HINCH

Below: Wolves are social creatures and use a lot of different body language to communicate with other wolves. These two were born in the spring, but now in early autumn, they're nearly full grown. The wolf on the right has taken a submissive posture toward its sibling, as evidenced by its tail tucked between its hind legs. STEPHEN C. HINCH

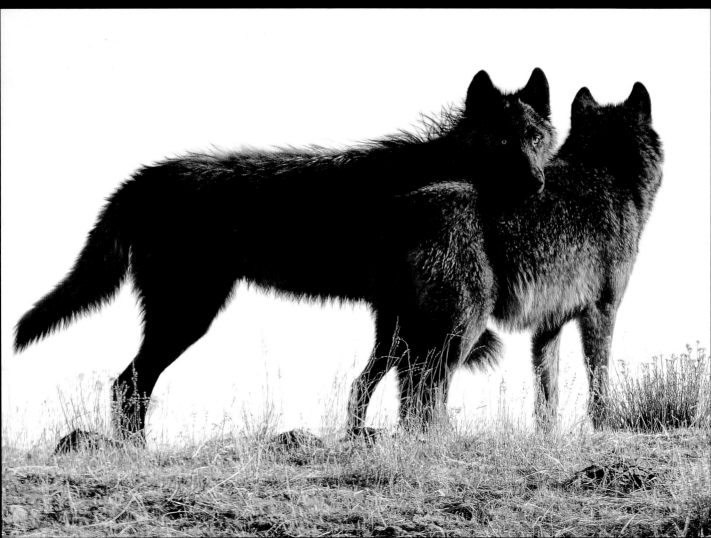

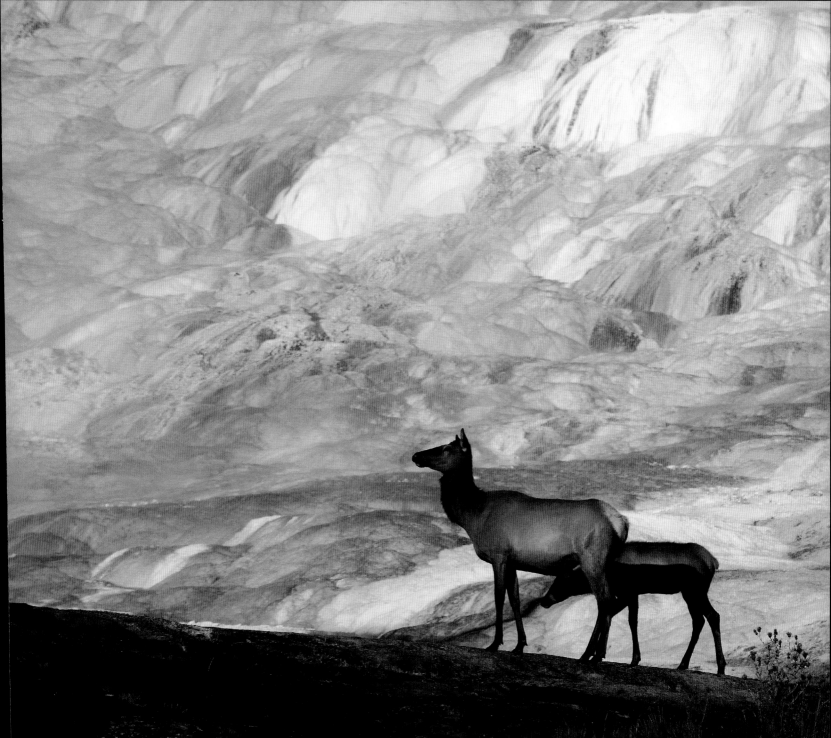

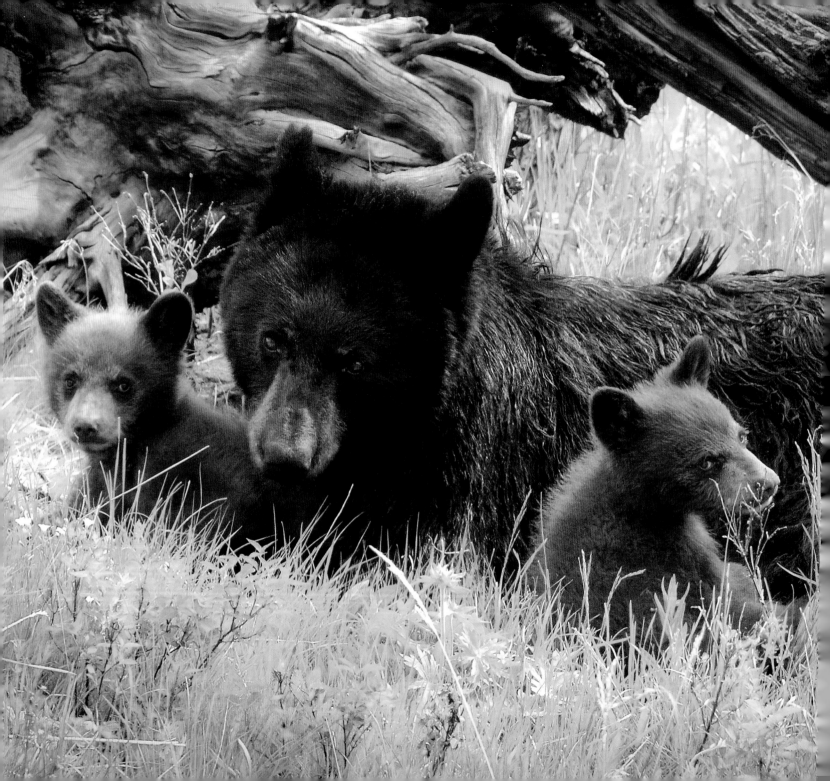

Left: Black bears can come in a variety of colors including black, brown, cinnamon, and even blonde. And the cubs of a black bear sow can often be a different color than her, as seen here. These two cinnamon-colored black bear cubs enjoy a moment of relaxation in the sun as they keep an eye on the crowd of people watching them. STEPHEN C. HINCH

Below: Badgers have a reputation for being nasty and mean. Watching a badger family at play certainly does nothing to dispel that reputation, as the young badgers wrestle quite aggressively. But play is still fun and also teaches the babies skills that will help them survive against larger predators when they grow up. STEPHEN C. HINCH

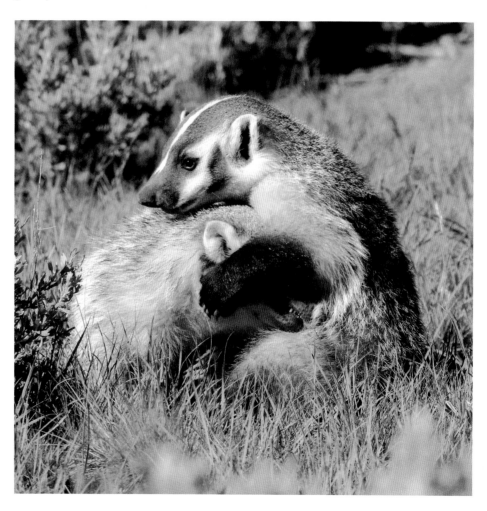

Right: By autumn, bighorn lambs aren't so little anymore, and they may have small horns already growing. This little one peered at me from behind its mother's back, appearing to give me a wink. Ewes will grow horns, but they tend to be short and just a spike, while rams will grow full curls. It takes a long time for a ram to grow a full curl, and only mature rams sport the biggest horns. STEPHEN C. HINCH

Far right: Newborn pronghorn fawns are quite small. The beautiful purple lupine flowers around this young fawn are perhaps only 8 to 10 inches in height, giving some perspective to the fawn's size. By autumn, it will be almost the size of its mother. STEPHEN C. HINCH

Below: Red fox kits are perhaps the most playful of Yellowstone's youngsters. Wrestling and launching sneak attacks are some of their favorite pastimes. Jumping through the air toward its sibling, this little one is not only strengthening its muscles but learning hunting skills, too. But for now, it's just a lot of fun! STEPHEN C. HINCH

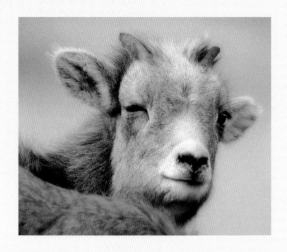

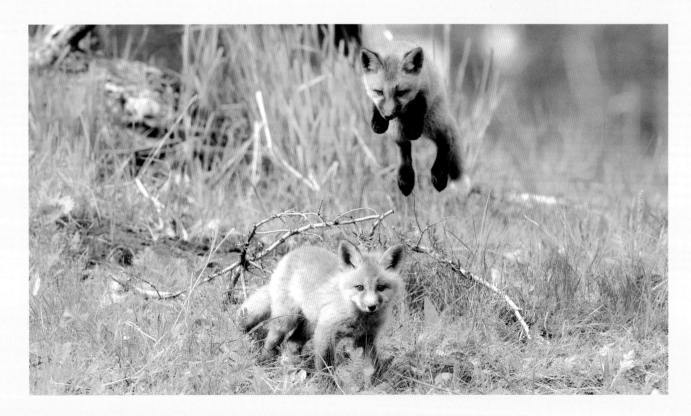

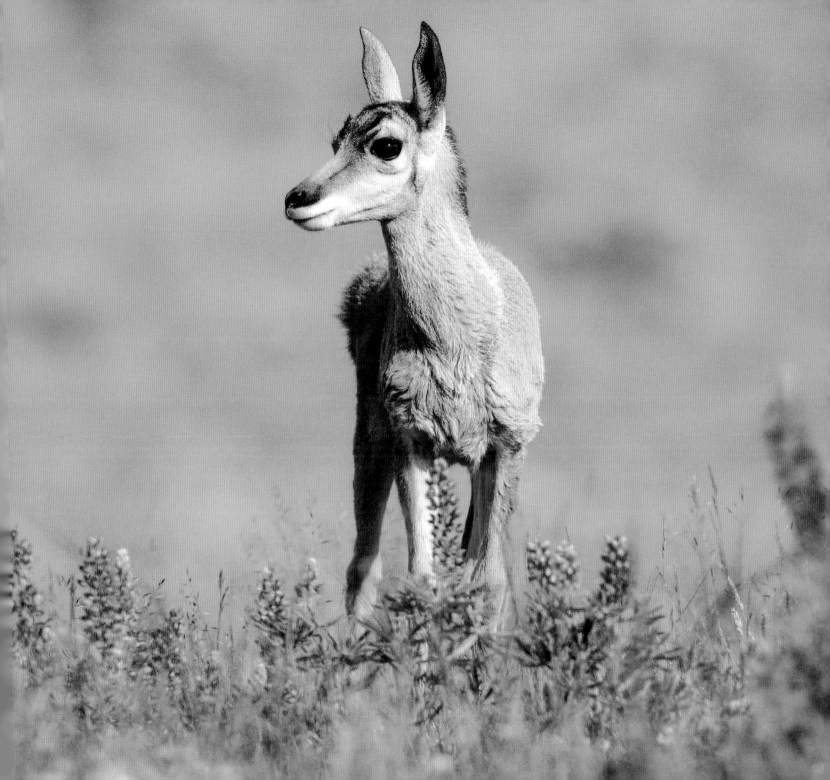

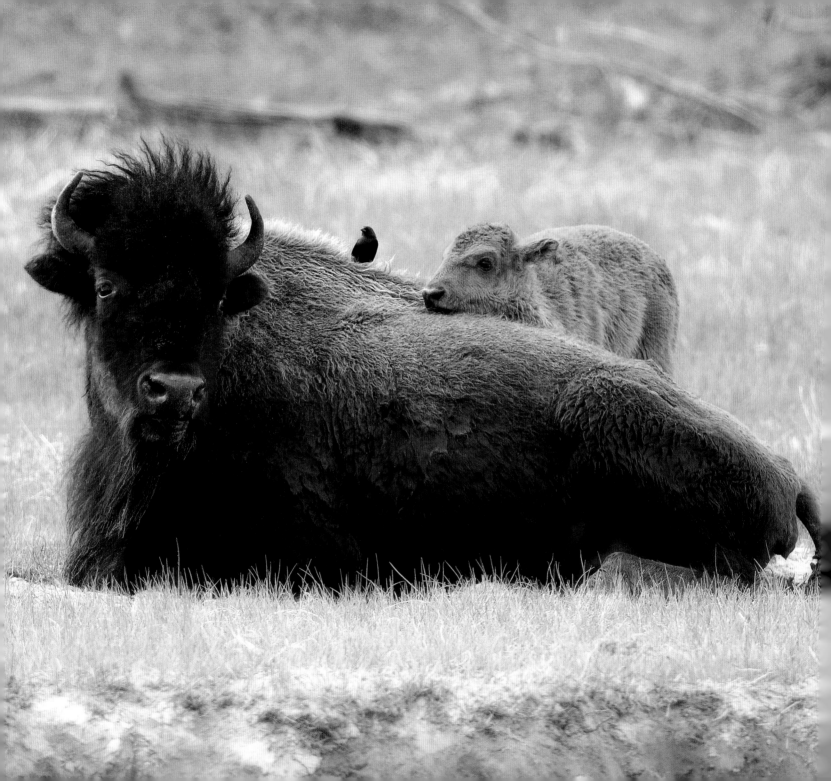

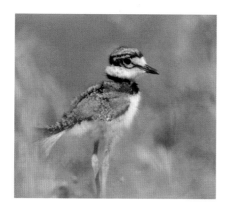

Left: A killdeer chick tries to stay hidden in tall grass after leaving the nest. Its parents are watching from close by, ready to fake a broken wing if needed to distract predators such as badgers, coyotes, or foxes. HENRY H. HOLDSWORTH

Far left: Sometimes moms are just good to use as a place to rest your head—or perhaps by nonchalantly resting on mom, this calf could get a better look at the cowbird also resting on momma's back. Either way, at least two critters thought this cow bison made a good place to take a quick rest break. STEPHEN C. HINCH

Below: Canada geese are common throughout Yellowstone, and in June it's easy to find some goslings. Though they start out quite small, goslings grow quickly, and it's not long before they start to resemble the large adults. Many geese migrate south during Yellowstone's long winters, but many also stay and are frequently seen on rivers that don't freeze over. STEPHEN C. HINCH

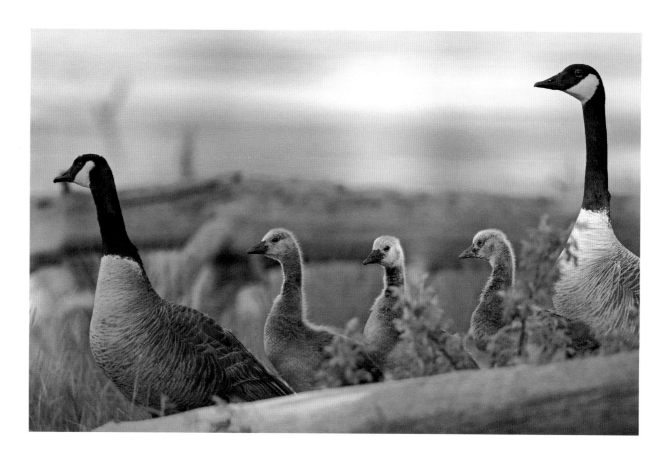

Right: A young pair of least chipmunks greet each other warmly in the golden sunlight of an early morning. HENRY H. HOLDSWORTH

Far right: Bear 399 and one of her two-year-old cubs take a stroll through bright yellow balsamroot flowers near Pilgrim Creek, east of Jackson Lake in Grand Teton. HENRY H. HOLDSWORTH

Below: A bison calf stops to smell the flowers in a patch of arrowleaf balsamroot on Antelope Flats in Grand Teton National Park. HENRY H. HOLDSWORTH

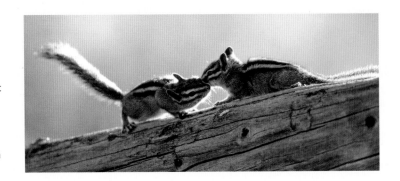

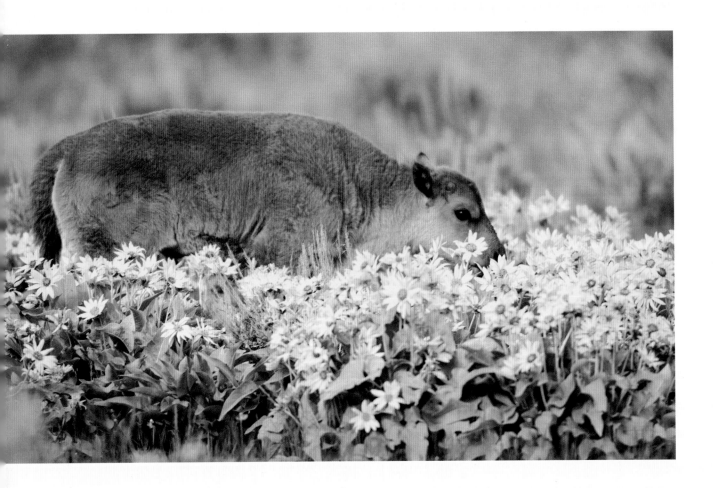

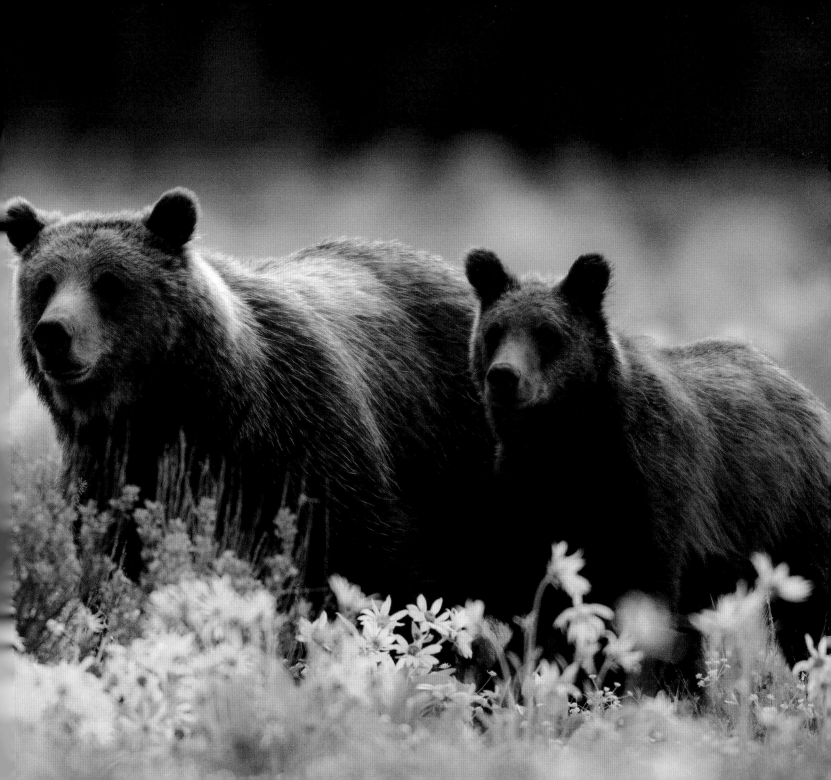

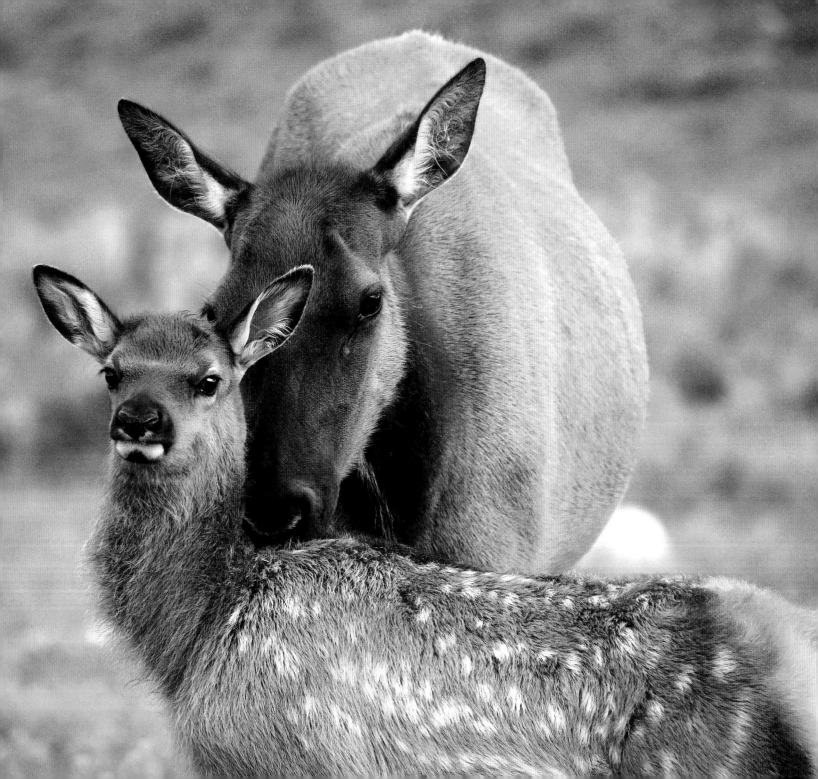

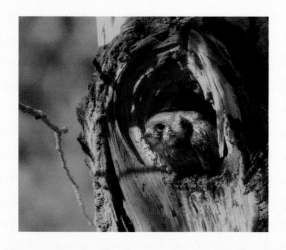

Left: Many raptors call Yellowstone home, but of all those raptors, only three species of falcons nest in the park. The smallest is the American kestrel, a robin-sized raptor that hunts mostly insects and small rodents. They nest in tree cavities, as seen here, where a young kestrel steps out to stretch its wings. STEPHEN C. HINCH

Far left: Elk are one of the most easily seen large mammals in Yellowstone and can be found in a variety of habitats, most commonly in open meadows. Cow elk leave their young hidden in tall grass or near fallen logs or rocks while they graze. When older and stronger, the calves will stay with the cow. STEPHEN C. HINCH

Below: White-tailed deer are scarce in Yellowstone, preferring lower elevations than those found on the park's high plateau. This doe with its nearly full-grown youngster were near the park's north entrance at Gardiner, Montana, where they searched the beautiful autumn grasses for forage. An easy way to tell the difference between white-tailed and mule deer is the tail. Mule deer have a rope-like tail compared to the fluffy one of the whitetail. STEPHEN C. HINCH

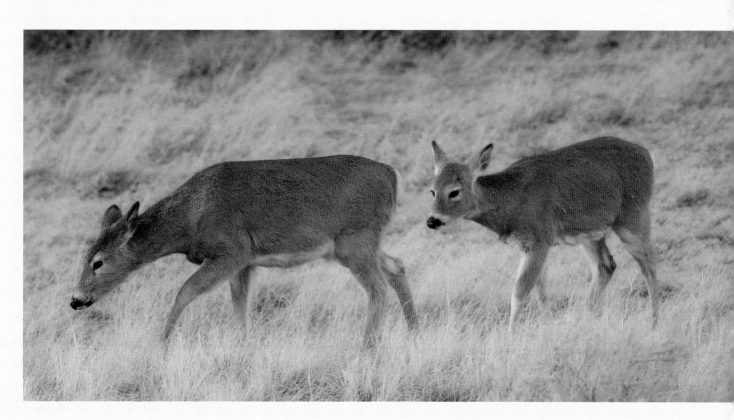

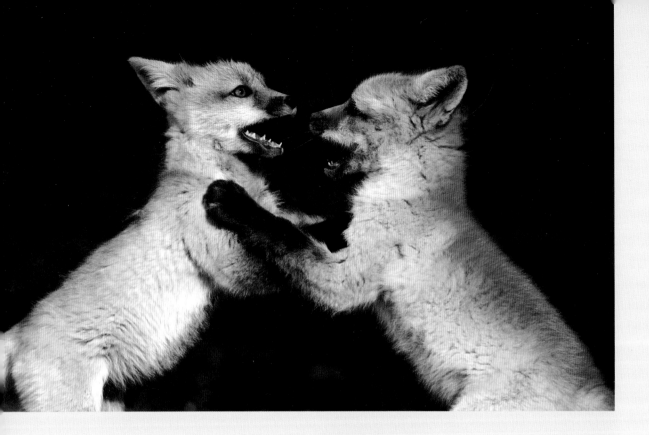

Above: Wrestling is always a fun way to spend time while waiting for mom to return home with dinner. These two red fox kits chased each other after one of them launched the surprise attack which initiated this wrestling match. Soon a third kit joined in and the chase began again.
STEPHEN C. HINCH

Right: These fluffy, colorful American coot chicks will grow up to be pure black adult birds with a white beak. HENRY H. HOLDSWORTH

Far right: Trumpeter swans mate for life. This pair shows off their tiny cygnets along Flat Creek on the National Elk Refuge. HENRY H. HOLDSWORTH

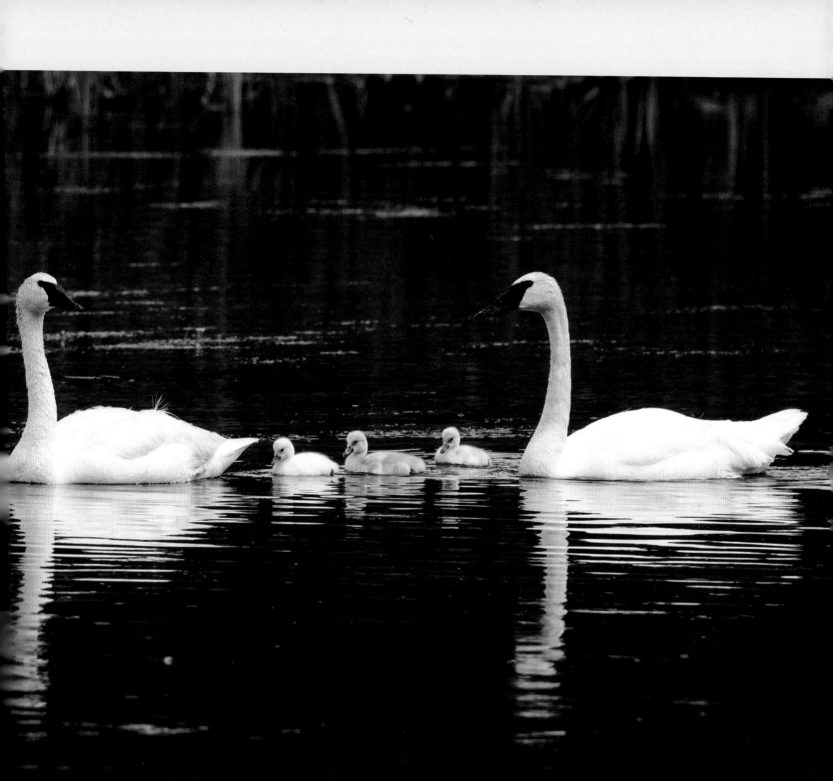

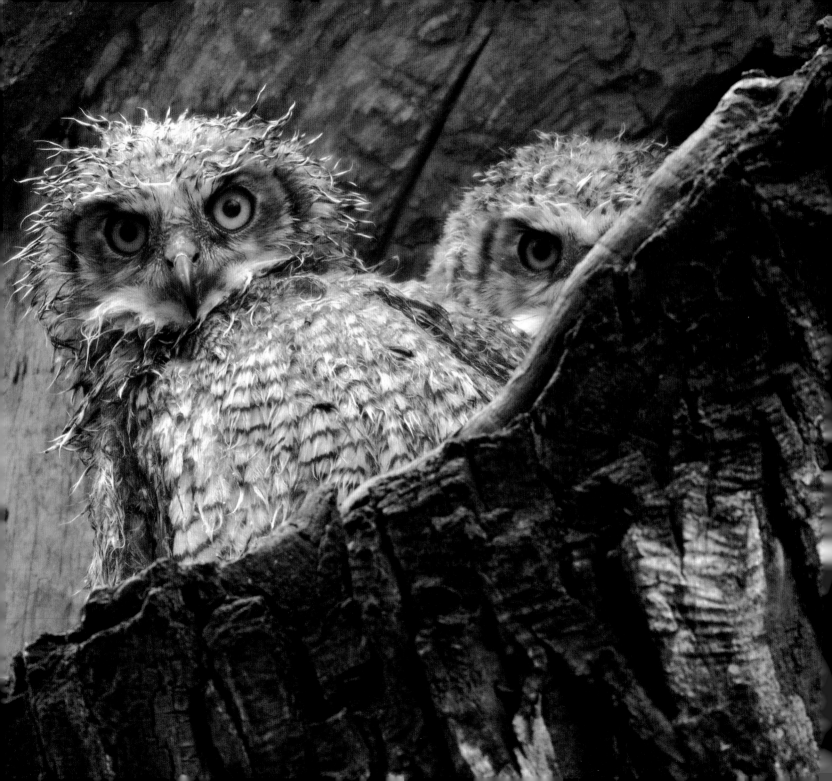

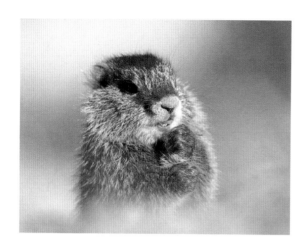

Left: A baby marmot pops up from among the rocks near its den. Marmots are born in the den in late spring or early summer, and by midsummer appear around the family's colony, where they play or simply enjoy the sun. Yellow-bellied marmots can live up to 15 years, though they spend a lot of that time hibernating. STEPHEN C. HINCH

Far left: A soaking wet great horned owl chick is having a bad hair day on a rainy spring afternoon. HENRY H. HOLDSWORTH

Below: The common merganser is frequently seen in Yellowstone, and mothers with young can be spotted on waterways during the summer months. The merganser is a fish-eating duck; its bill is designed for catching and holding on to small fish. Young mergansers learn to fly about two months after hatching. STEPHEN C. HINCH

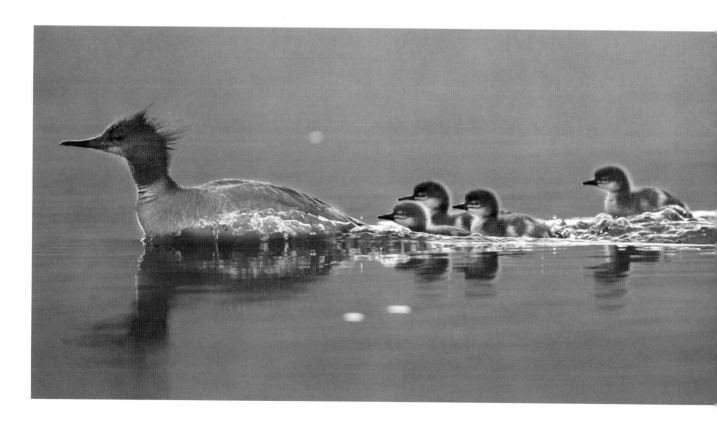

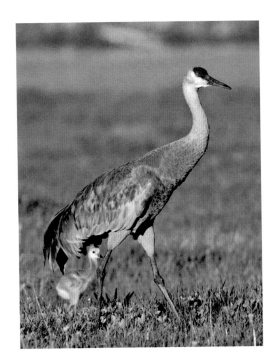

Right: A sandhill crane takes her two-week-old colt for a walk. If this colt can make it through its first few years, it could live to be fifteen to twenty years old.
HENRY H. HOLDSWORTH

Far right: This bison herd full of newborn calves takes advantage of a seasonal watering hole near Shadow Mountain.
HENRY H. HOLDSWORTH

Below: A female Barrow's goldeneye keeps a watchful eye on her brood of ducklings at Schwabacher's Landing.
HENRY H. HOLDSWORTH

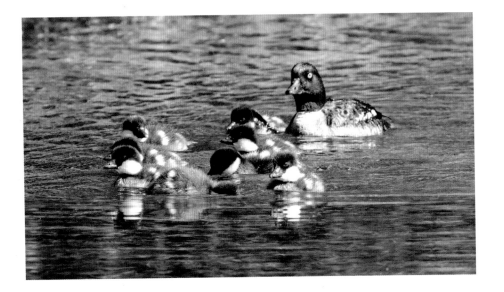

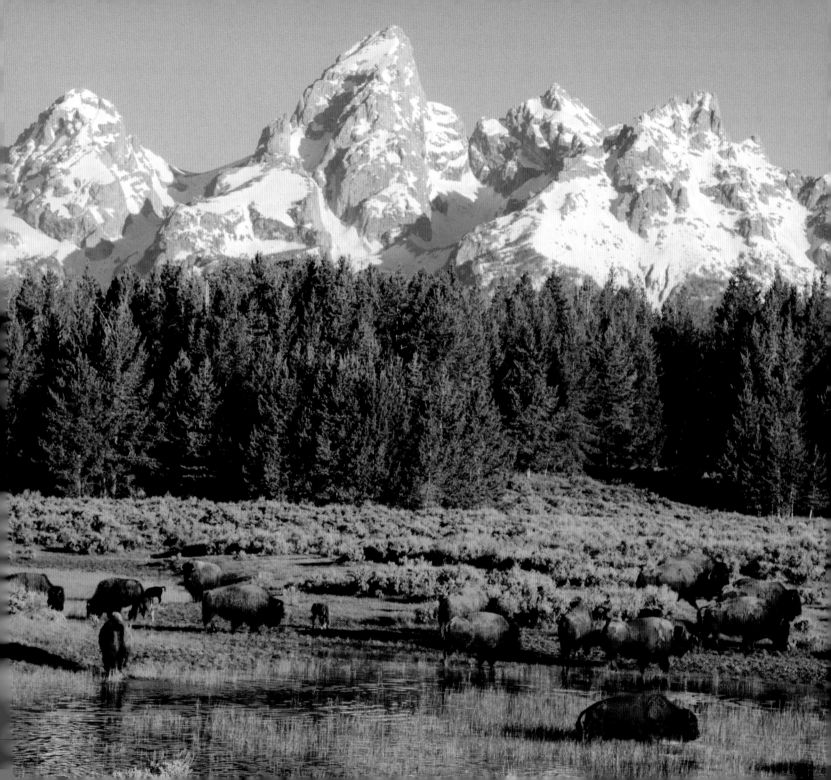

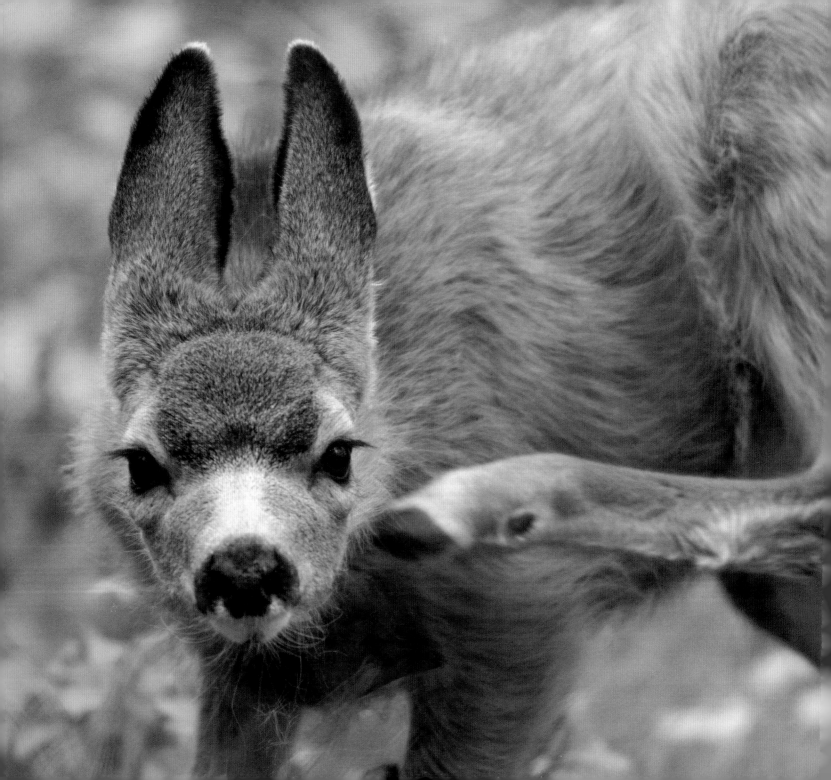

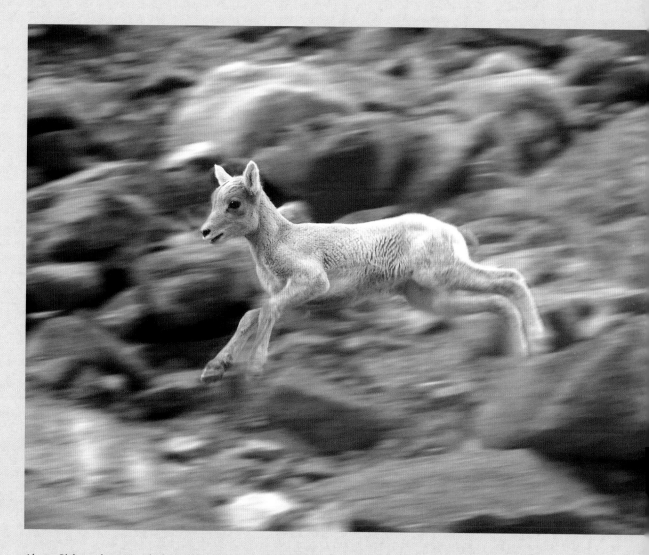

Above: Bighorn sheep spend a lot of time on or around cliffs, which is a natural defense against predators. So bighorn lambs learn quickly how to negotiate the steep cliffs they call home. This lamb was deftly chasing after its mother along a rocky cliff face. STEPHEN C. HINCH

Left: This mule deer fawn is just itching for its fall coat to come in. HENRY H. HOLDSWORTH

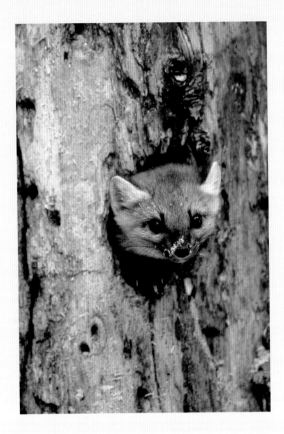

Above: A young pine marten searches for a meal inside a hollowed-out tree. HENRY H. HOLDSWORTH

Right: Thermal areas can provide warmth during Yellowstone's long and harsh winters, and occasionally elk may be found around a geyser or hot spring. This young elk, probably experiencing its first winter, finds itself face to face with Old Faithful Geyser. The warmth from the thermal activity keeps the area clear of snow, making it easy for wildlife to find any meager grasses to graze. STEPHEN C. HINCH

Facing page: Great horned owl chicks stay cozy underneath their mom in the heart of a cottonwood tree on a cold morning in May. HENRY H. HOLDSWORTH

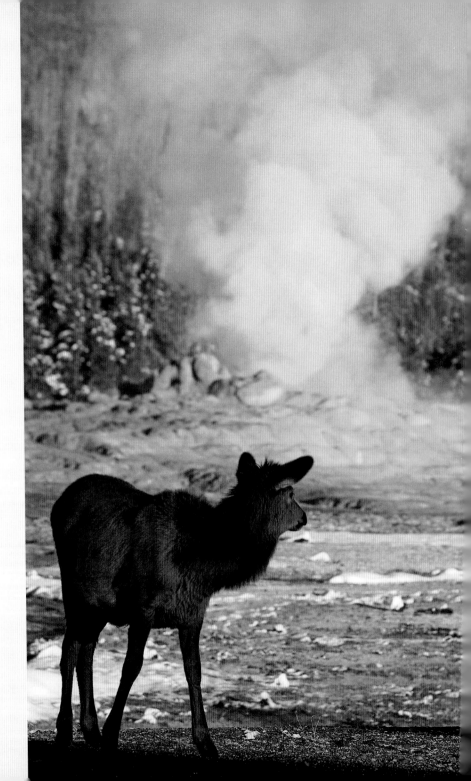

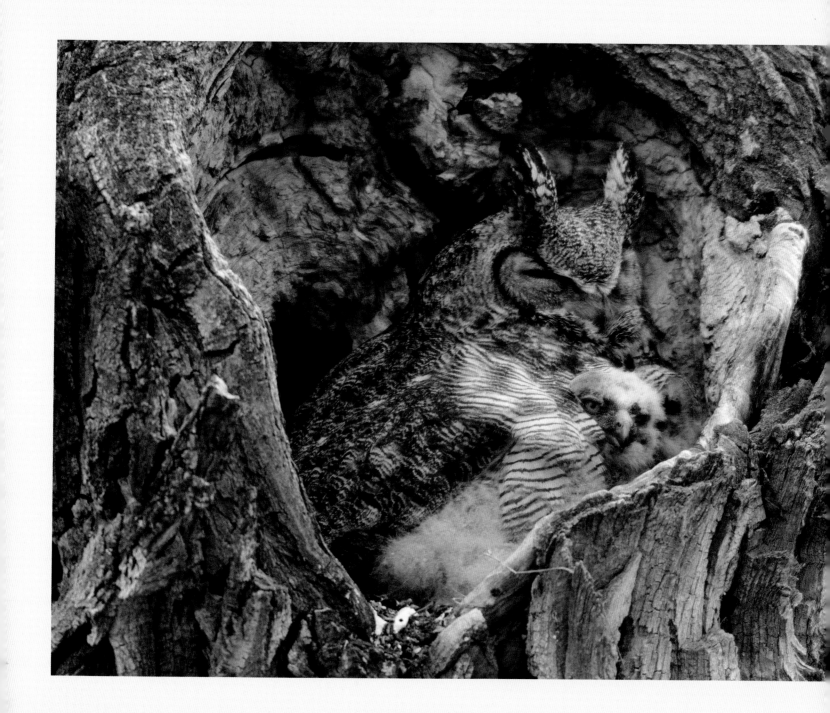

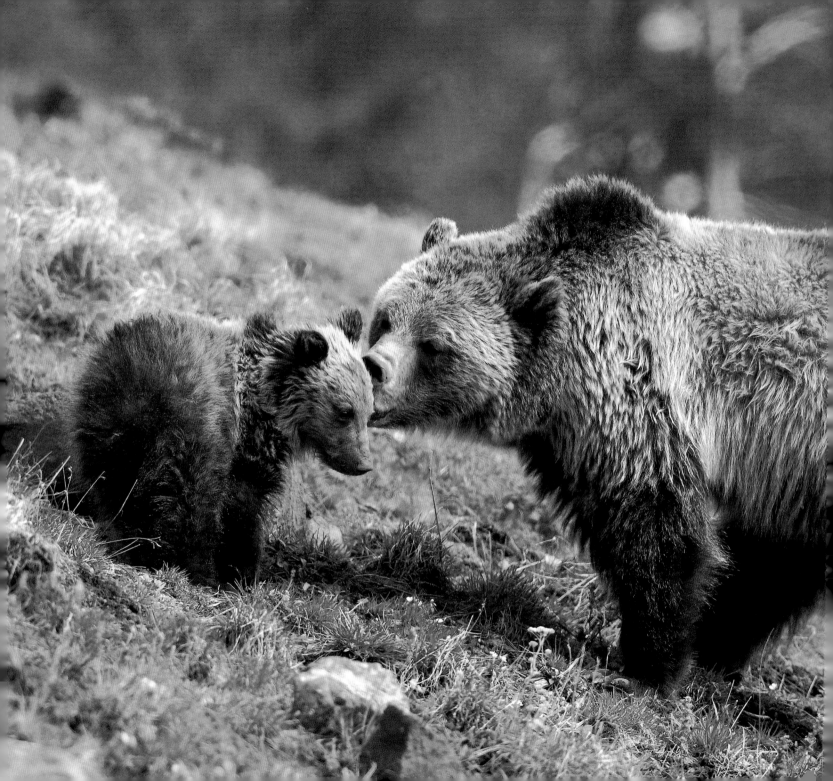

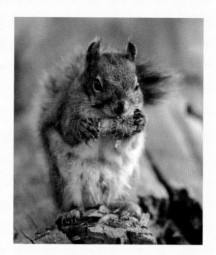

Left: A young red squirrel makes a meal of pine nuts deep in a lodgepole forest. HENRY H. HOLDSWORTH

Far left: Everyone needs to be comforted sometimes. What looks like a kiss here is actually something similar. This small cub became frightened when a big truck drove by and its brakes made a loud noise. The cub ran back to its mother, who comforted her cub by nipping at its nose and caressing its face with her nose. The cub calmed down, and this was followed by a nursing session. STEPHEN C. HINCH

Below: Babies are curious creatures, and bison babies are no exception. Bison calves love to play, but when all the other calves are sleeping, cowbirds can be fun to watch, too. STEPHEN C. HINCH

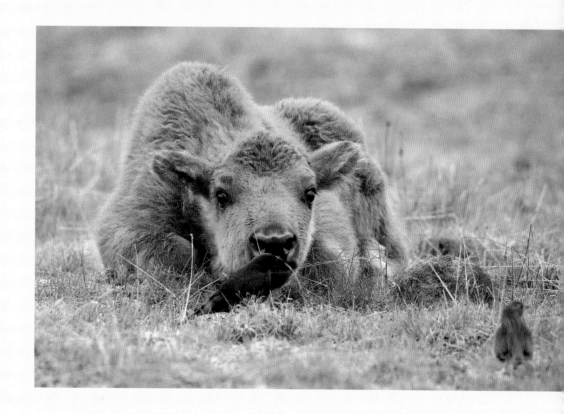

Right: Adult Canada geese are among the largest waterfowl in Yellowstone, but their goslings can be quite small. These two were hidden in the tall grass along the Madison River, only appearing when they poked their heads up to take a look around. STEPHEN C. HINCH

Far right: Two moose calves stick together like Siamese twins. Moose can have one, two, or three calves at a time. Although I have never seen triplets, there are usually several sets of twins born in the Tetons each spring. HENRY H. HOLDSWORTH

Below: River otters of any age are fun to watch. This young pup was pretty curious about this particular log and spent a great deal of time investigating. Perhaps it could smell the markings of another otter, or maybe a fish had been eaten here and the odor remained. Whatever it was, it was too good not to sniff. STEPHEN C. HINCH

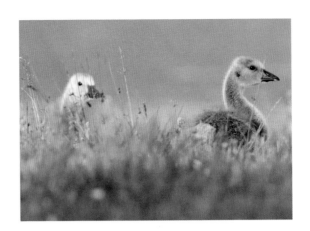

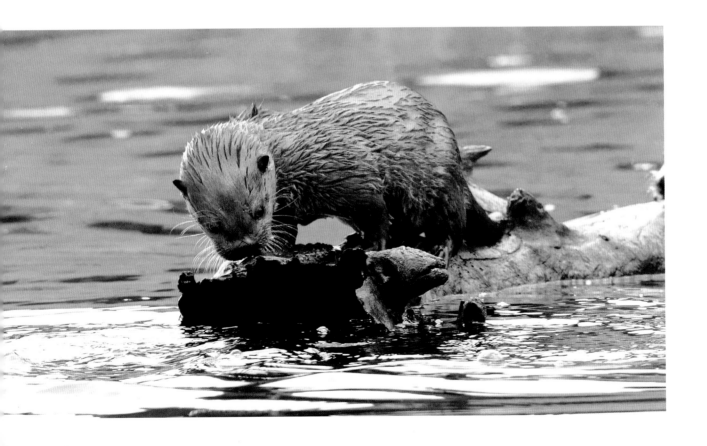

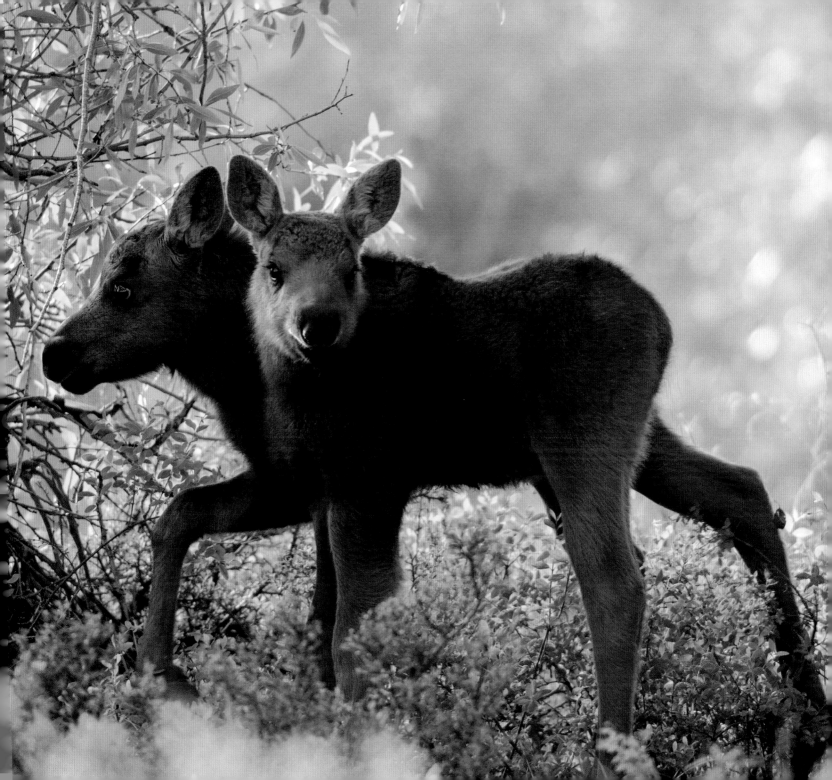

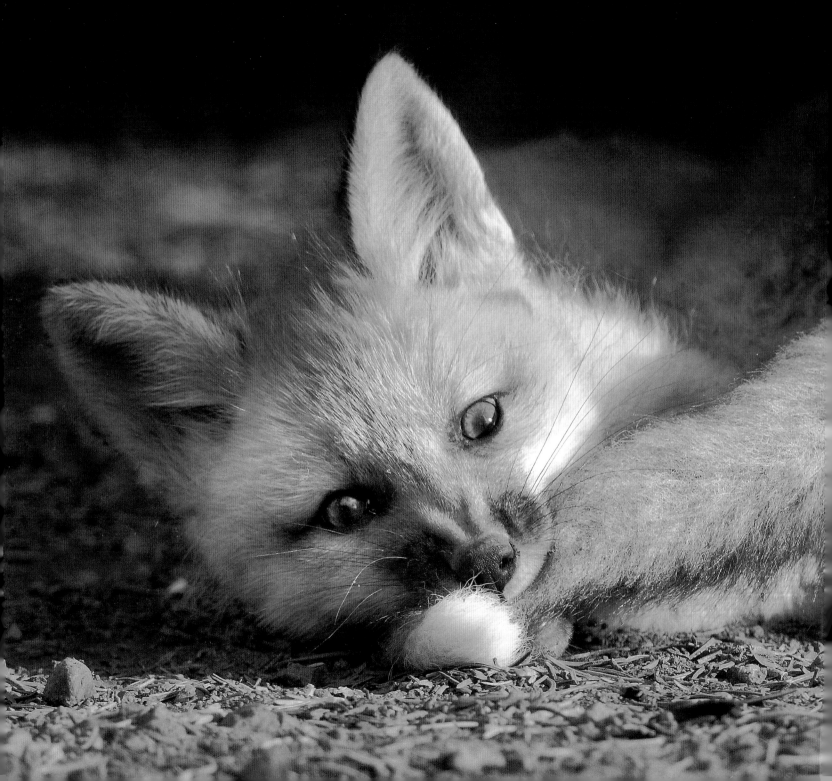

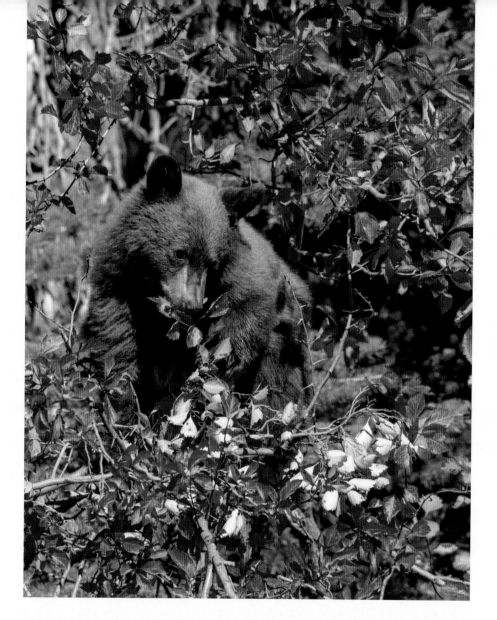

Above: Gorging itself on hawthorn berries in October, this young black bear cub is eating as much as it can before heading toward hibernation in late November. HENRY H. HOLDSWORTH

Left: When you can't find a stick to chew, make do with what you have. In this case, a sibling's tail makes the perfect toy for this mischievous red fox kit. Kits will play with anything. Bones, sticks, rocks, clumps of dirt, feathers—basically anything they can find—make great toys. STEPHEN C. HINCH

STEPHEN C. HINCH

Award-winning photographer Steve Hinch has photographed the greater Yellowstone area for over twenty years and has resided full-time in West Yellowstone for over fourteen. Through his wildlife and scenic landscape images taken across the country, Hinch shares unique views of nature as they happened in a single moment in time.

Hinch's images have been featured in a variety of publications and collections, including the Smithsonian Institution National Museum of Natural History.

To see more of Steve Hinch's photography, visit www.stevehinchphotography.com.

HENRY H. HOLDSWORTH

Henry Holdsworth has spent over thirty-five years photographing the wildlife and landscapes of Grand Teton National Park. Educated as a biologist with a background in animal behavior, Henry has traveled extensively, but there is no place he enjoys photographing more than his own backyard, Grand Teton National Park.

Henry has published ten books on the region with Farcountry Press, and his work has appeared in many publications such as *National Geographic, Ranger Rick*, and *National Wildlife*.

Henry currently divides his time between photographing, teaching photography workshops, and running his Wild by Nature Gallery in Jackson Hole, www.wildbynaturegallery.com.